A Visual Journey

Un recorrido pictórico

Un périple en images

写真で見る活動の軌跡

비쥬얼 여행

Trajetória em Imagens

Rotary International

FRONT COVER • INDIA 2008 •

To promote polio immunization efforts, Rotarian volunteers give out masks and other small gifts to millions of children during National Immunization Days in India and other polio-endemic countries. Rotary's leadership in the global polio eradication campaign has helped to reduce the incidence of polio by more than 99 percent.

A fin de promover la gestión de vacunación contra la polio, los voluntarios rotarios reparten máscaras y otros presentes a los niños durante las Jornadas Nacionales de Vacunación en India y otros países polioendémicos. El liderazgo de Rotary en la campaña mundial de la erradicación de la polio ha contribuido a reducir la incidencia de esta enfermedad en más del 99 por ciento.

Pour promouvoir les efforts de vaccination contre la polio, les Rotariens distribuent des masques et autres cadeaux à des millions d'enfants à l'occasion des Journées nationales de vaccination en Inde et dans d'autres pays endémiques. L'élan donné par le Rotary à la campagne mondiale pour l'éradication de la polio a permis de réduire de 99 % le nombre de cas.

インドの全国予防接種日や、その他ポリオ問題を抱える国々で、ロータリアンは、予防接種活動の一環として、何百万人もの子供たちにマスクなどのグッズを配布しています。世界的なポリオ撲滅キャンペーンにおけるロータリーのリーダーシップにより、ポリオの発症率は99%以上も減少しました。

인도 등 소아마비 발병국가에서 개최되는 전국 면역의 날 행사를 홍보하기 위해, 로타리안 자원봉사자들이 마스크를 비롯한 기념품들을 어린이들에게 나누어 주고 있다. 지구상에서 소아마비를 박멸하기 위한 국제로타리와 그 파트너 단체들의 노력에 힘입어 소아마비 발병률은 99 퍼센트가 줄어들었다.

Para promover a imunização contra a pólio, rotarianos distribuem máscaras e lembranças a milhões de crianças durante os Dias Nacionais de Imunização na Índia e em outros países endêmicos. O Rotary e seus parceiros na Iniciativa Global de Erradicação da Pólio já conseguiram reduzir a incidência da doença em 99%.

INTRODUCTION

Every day, in every part of the world, the 1.2 million men and women of Rotary are working to improve health, alleviate poverty, eradicate polio, promote literacy, and bring hope to millions of people in need. The images on these pages show the world through Rotary's eyes, a world in which all manner of human need is countered by creative Rotary service and Rotary's humanitarian army of volunteers. We invite you to turn the page and begin your visual journey through the inspirational world of Rotary.

INTRODUCCIÓN

Todos los días, en cada rincón del mundo, los 1,2 millones de hombres y mujeres de Rotary trabajan para mejorar la salud, paliar la pobreza, erradicar la polio, promover la alfabetización y traer esperanza a millones de personas necesitadas. Las imágenes en estas páginas muestran el mundo visto desde el iris de Rotary, un mundo en el que todo tipo de necesidad humana se contrarresta gracias a la creatividad de su servicio y a su ejército de voluntarios. Les invitamos a pasar la página y empezar su recorrido pictórico de este mundo tan inspirador de Rotary.

INTRODUCTION

Chaque jour dans le monde, 1,2 million de Rotariens, hommes et femmes, œuvrent pour améliorer la santé, réduire la pauvreté, éradiquer la polio, promouvoir l'alphabétisation et donner espoir à des millions d'êtres humains. Au fil des pages, ces photos montrent le monde au travers des yeux du Rotary, un monde dans lequel les Rotariens, véritable armée de bénévoles, sont en mesure de par leur ingéniosité et leur réseau humanitaire de répondre aux besoins. Nous vous invitons à effectuer un périple en images dans le monde du Rotary.

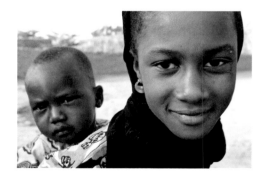

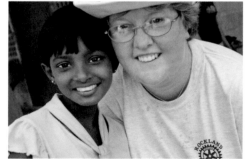

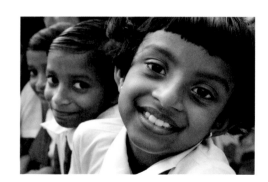

はじめに

世界中で日々120万人のロータリアンが、保健向上、貧困緩和、ポリオ撲滅、識字率向上などを通じ、支援を必要とする何百万人もの人々に希望を与えるために活動しています。ロータリーは、創造力あふれる奉仕や、人道的ニーズに対応しています。本写真集は、このような世界を、ロータリーの目線から紹介しています。この写真集で、ロータリーの素晴らしい世界を旅してみましょう。

소개말

전세계 120만 로타리안들은 오늘도 더나은 세상을 꿈꾸며, 자신이 살고 있는 지역사회와 지구촌 이웃을 위해 봉사 활동을 벌이고 있습니다. 이들은 보건 증진, 기아 완화, 소아마비 박멸, 문해력 증진에 힘쓰며, 절망에 빠져있는 수많은 사람들에게 희망을 불러일으키기 위해 노력합니다. 이 책의 사진들은 로타리의 눈을 통해서 본 세상입니다. 그 세상에서는 인간의 기본적인 필요들이 누구도 생각지 못했던 로타리 봉사에 의해 충족되고, 인간애로 무장한 로타리 자원봉사자들에 의해 해결됩니다. 이 책을 통해 독자 여러분을 로타리의 역동성을 체험하는 비쥬얼 여행으로 초대합니다.

INTRODUÇÃO

Todo dia, os 1,2 milhão de rotarianos trabalha para melhorar a saúde, aliviar a pobreza, erradicar a pólio, promover a alfabetização e levar esperança a milhões de pessoas carentes. As imagens destas páginas mostram o mundo através dos olhos do Rotary, um mundo em que as necessidades humanas são mitigadas por um exército humanitário de voluntários. Convidamos você a começar sua trajetória em imagens pelo universo inspirador do Rotary.

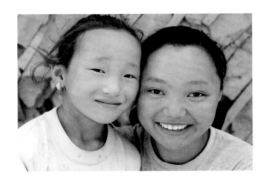

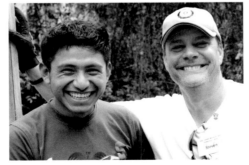

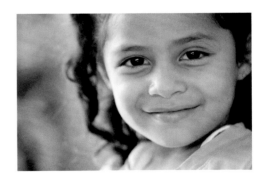

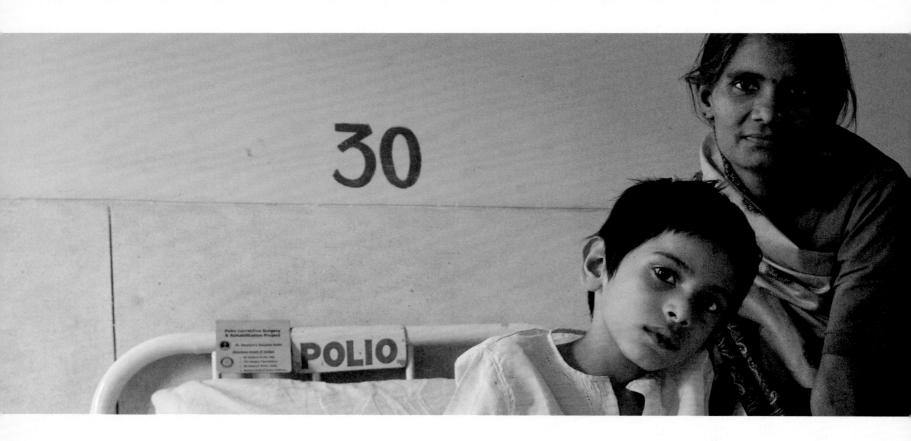

Eradicating polio globally

Erradicación mundial de la polio

Éradication de la polio dans le monde

世界的ポリオ撲滅活動

소아마비 박멸에 앞장서다

Erradicando a pólio globalmente

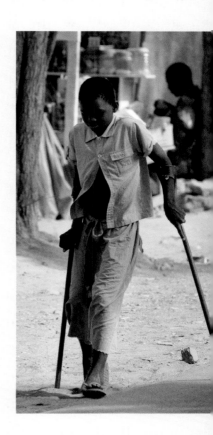

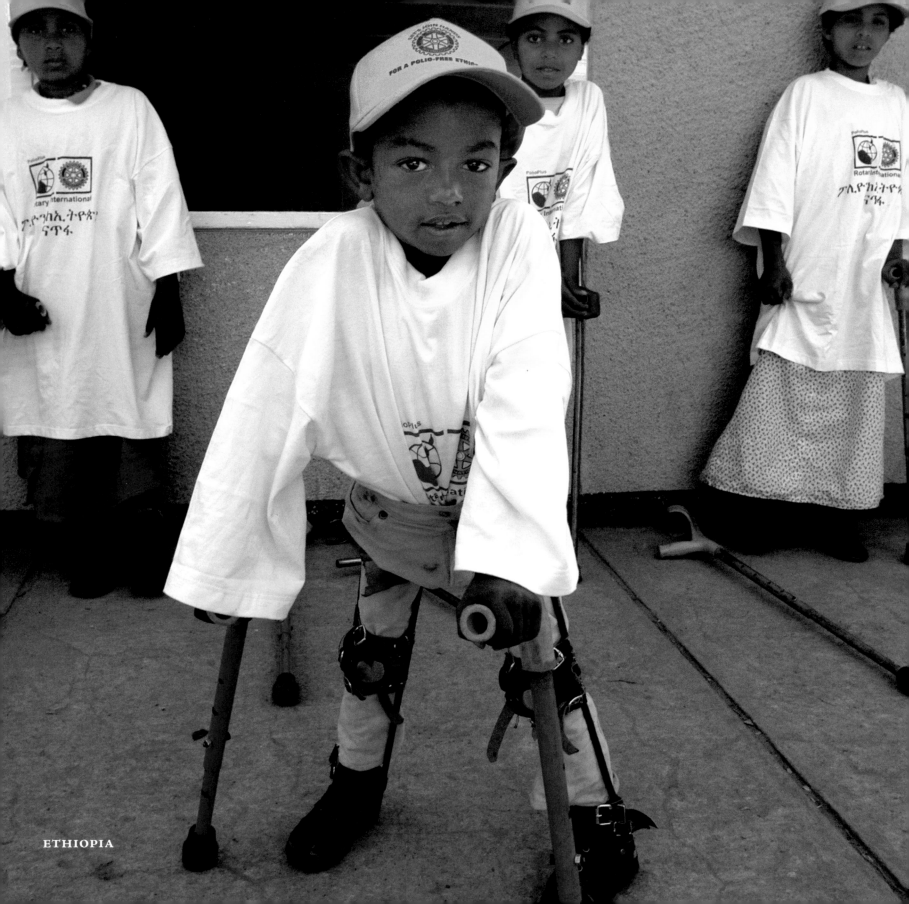

ETHIOPIA

NIGER

INDONESIA

INDIA

INDIA

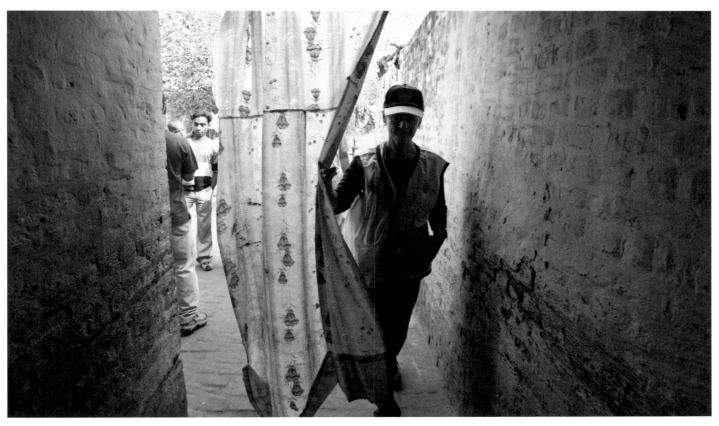

INDIA

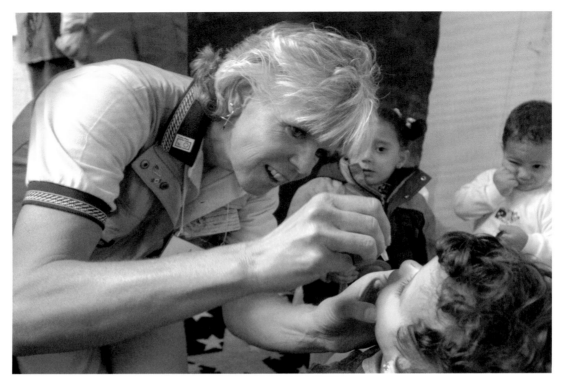

EGYPT

INDIA

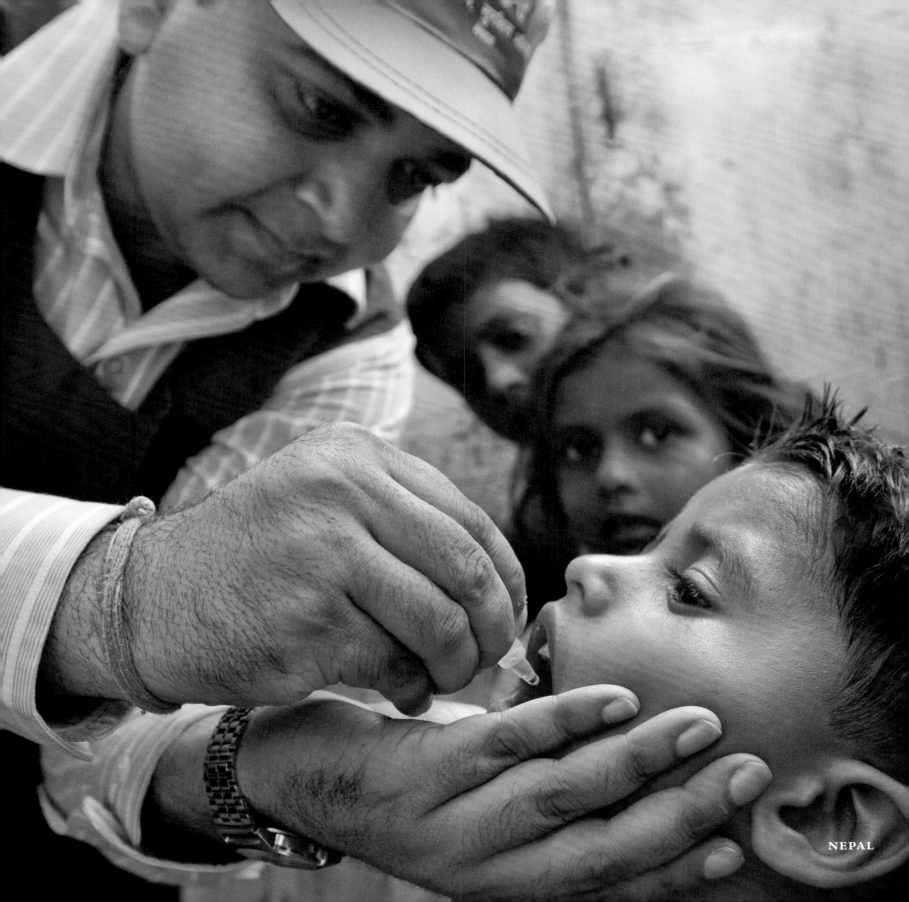

NEPAL

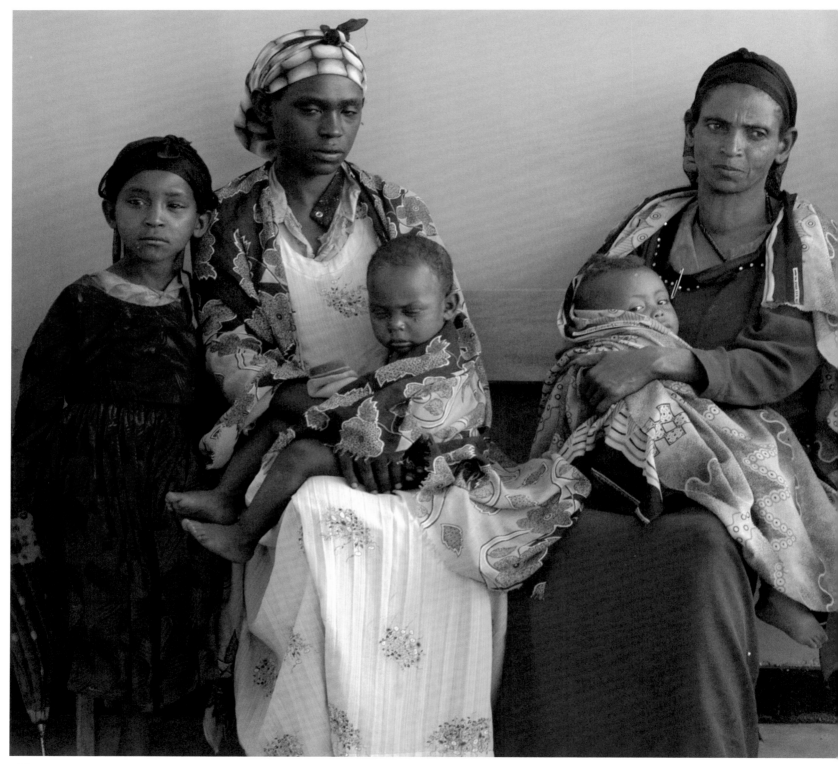

ETHIOPIA

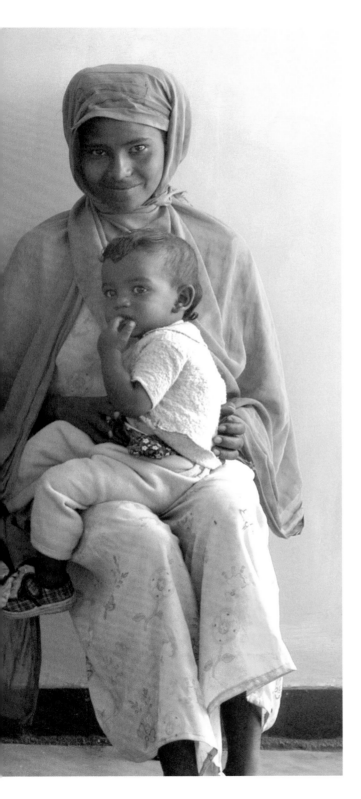

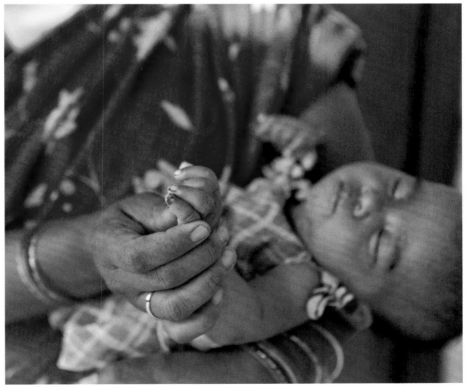

INDIA

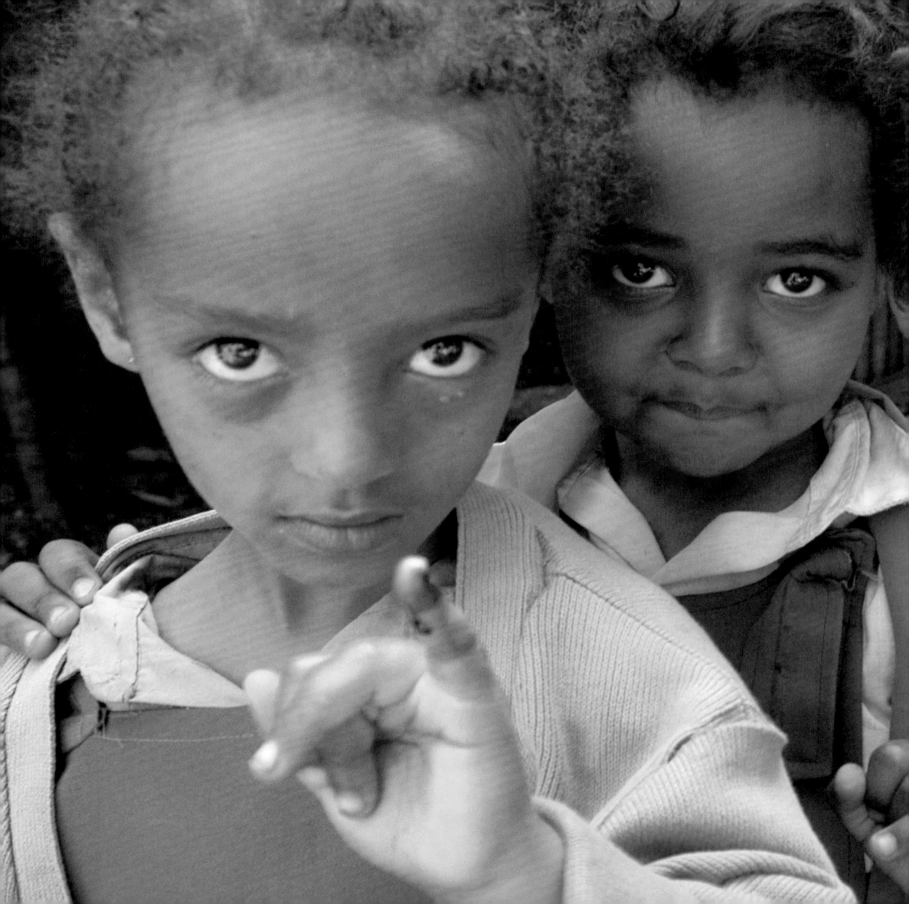

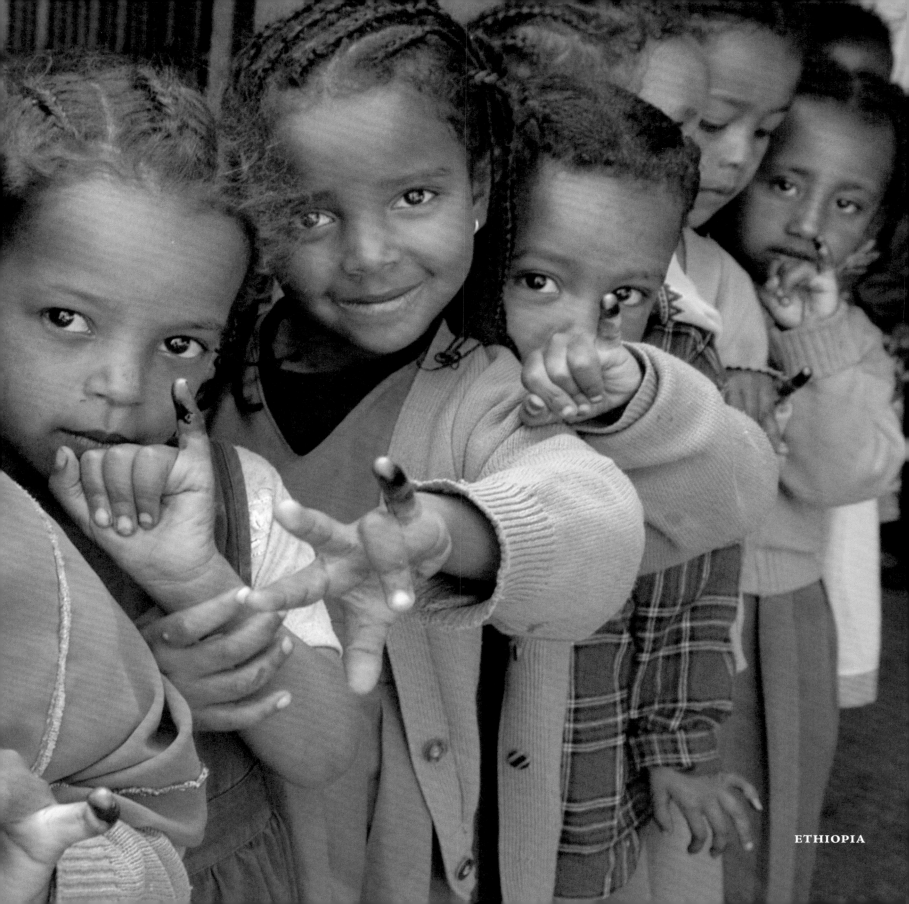

ETHIOPIA

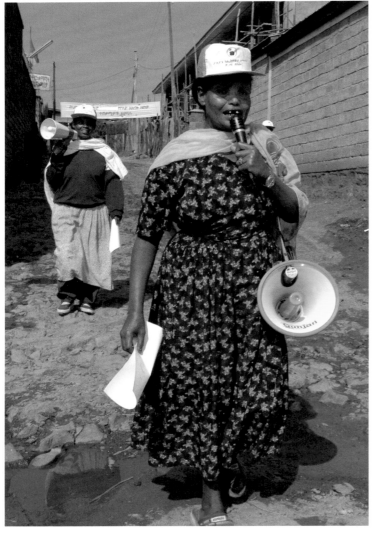

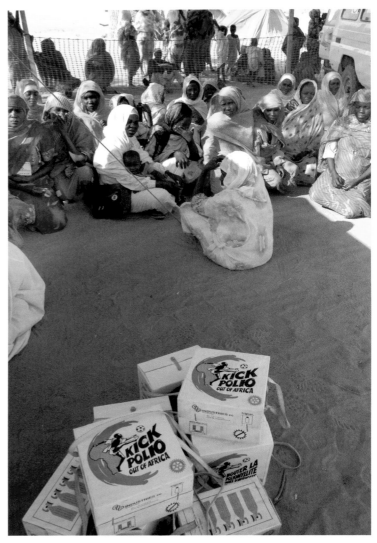

ETHIOPIA

CHAD

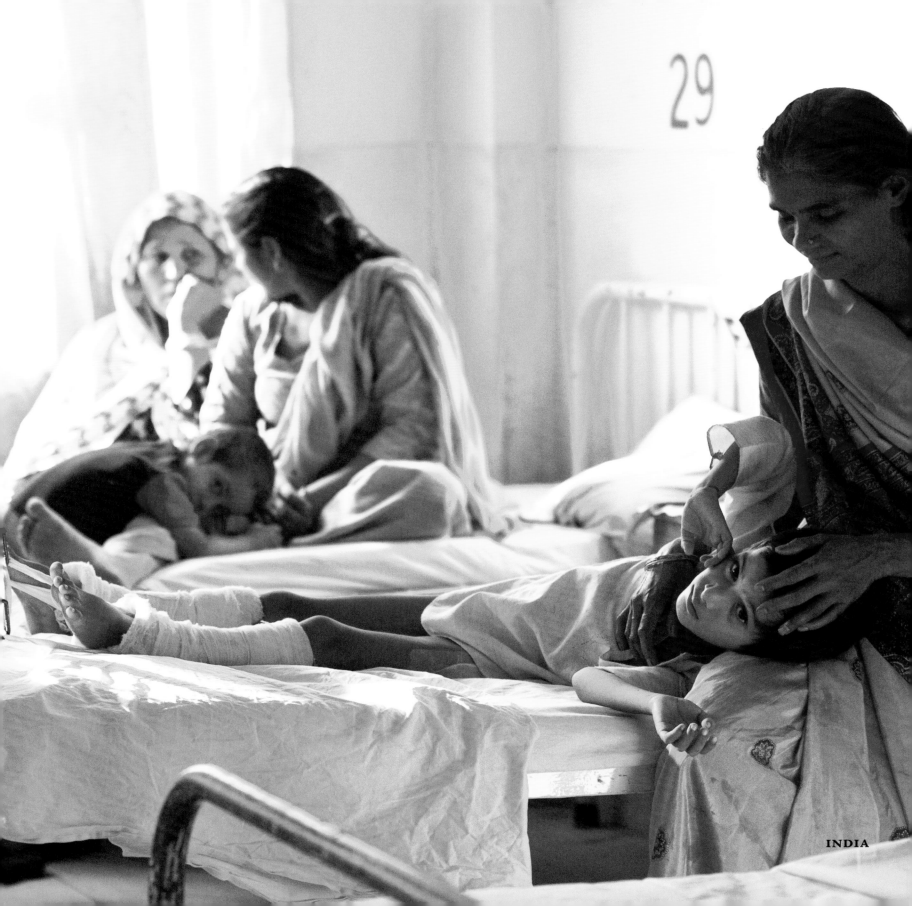

INDIA

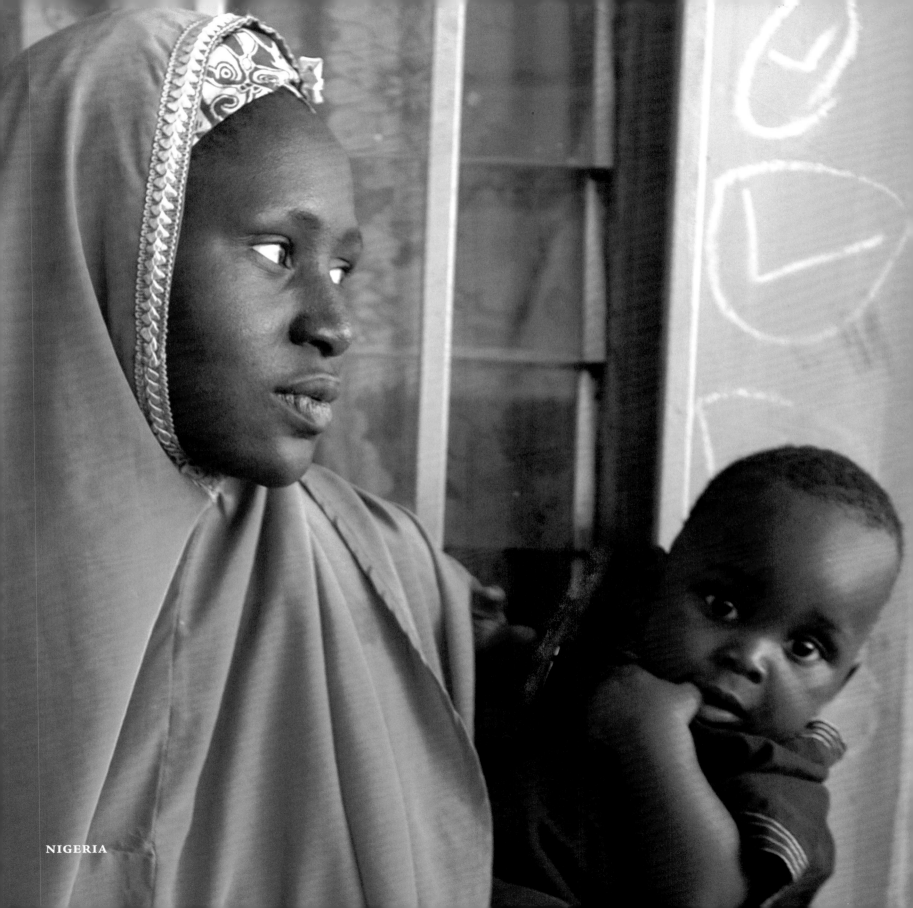

NIGERIA

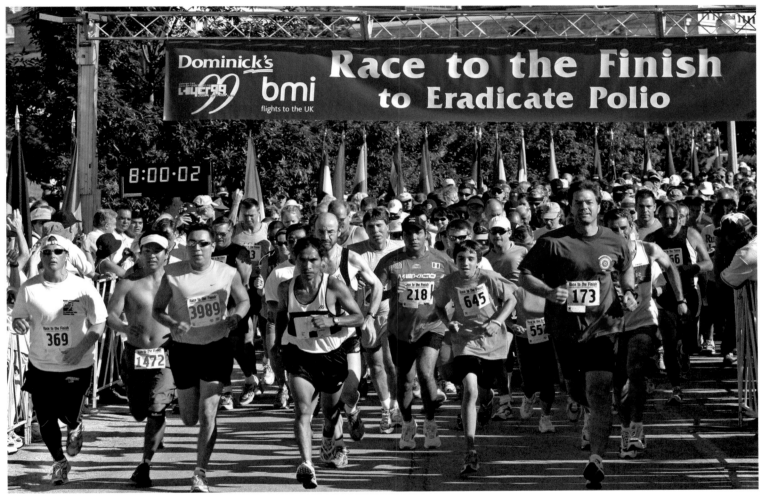

UNITED STATES

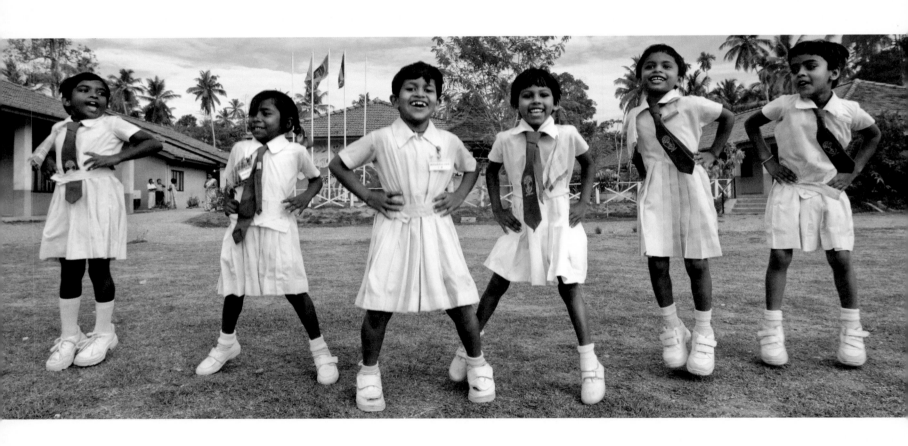

Meeting basic needs of food, health care, and education

Alimentación, atención a la salud y educación

Besoins alimentaires, sanitaires et éducatifs

食糧・保健・教育といった基本的ニーズに応える

식량, 보건, 교육 등 기본적인 필요 충족

Atendendo a necessidades básicas de alimentação, saúde e educação

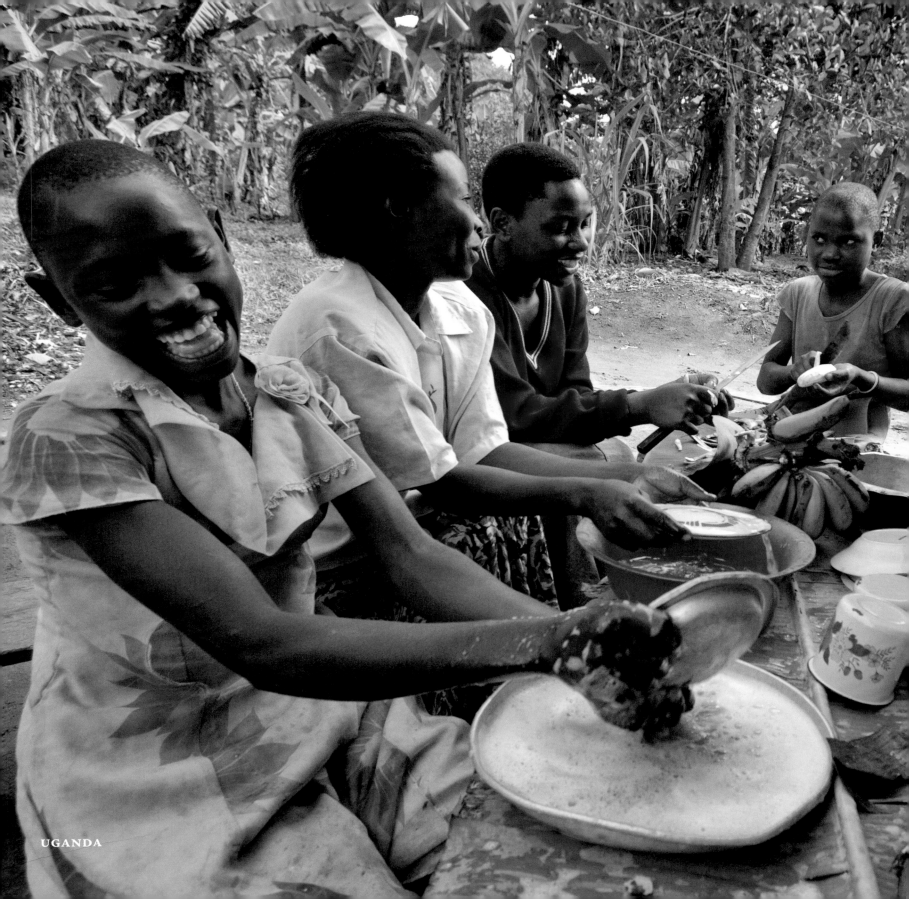

UGANDA

UGANDA

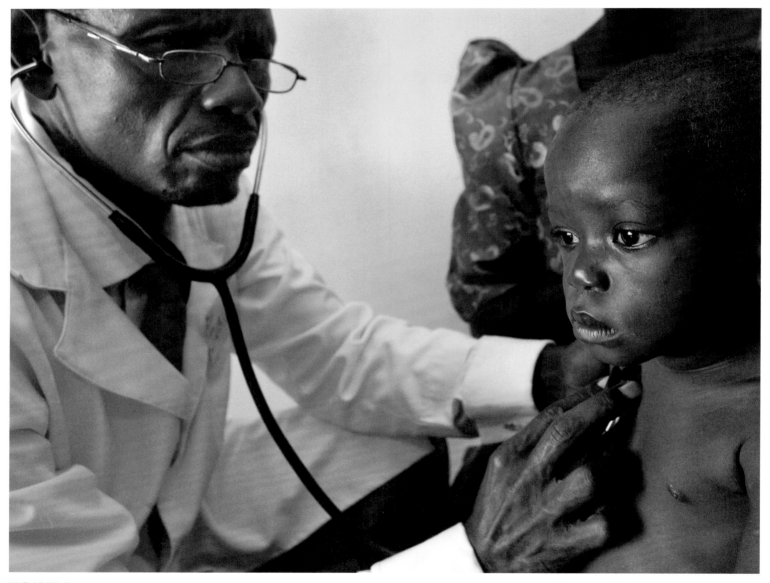

UGANDA

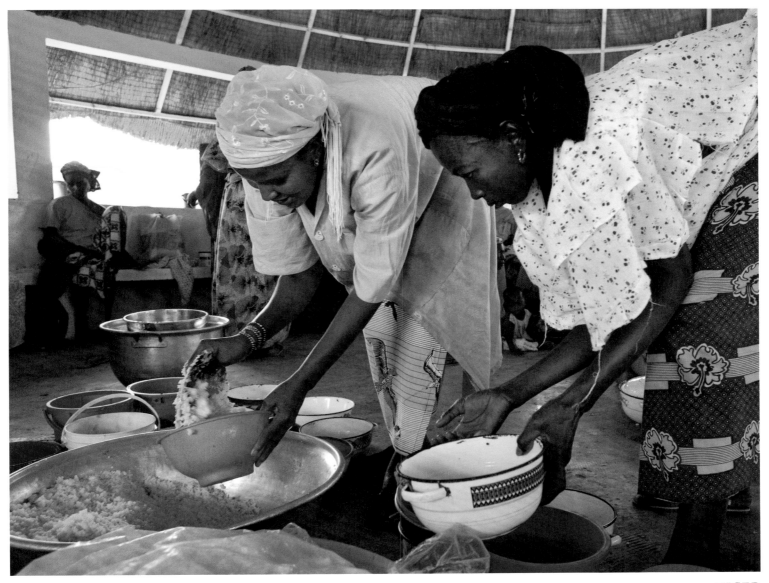

NIGER

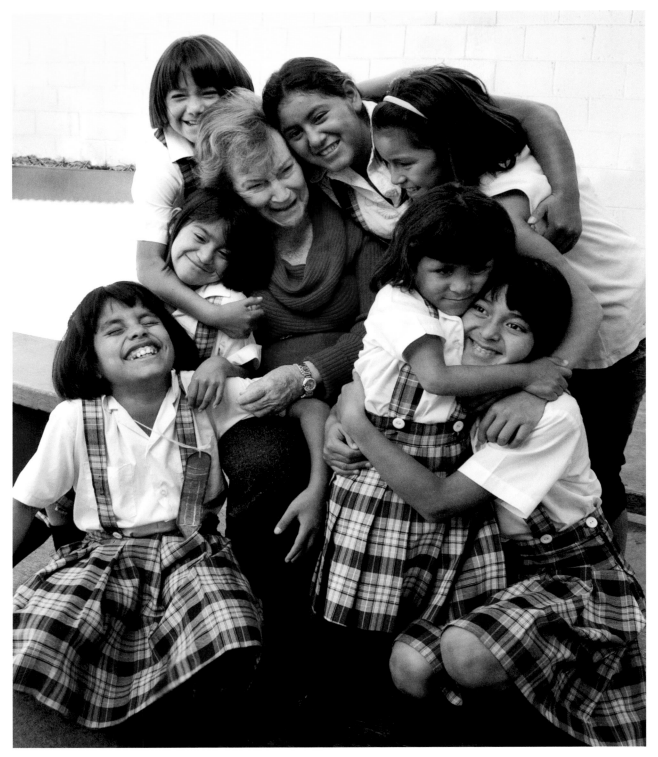

GUATEMALA

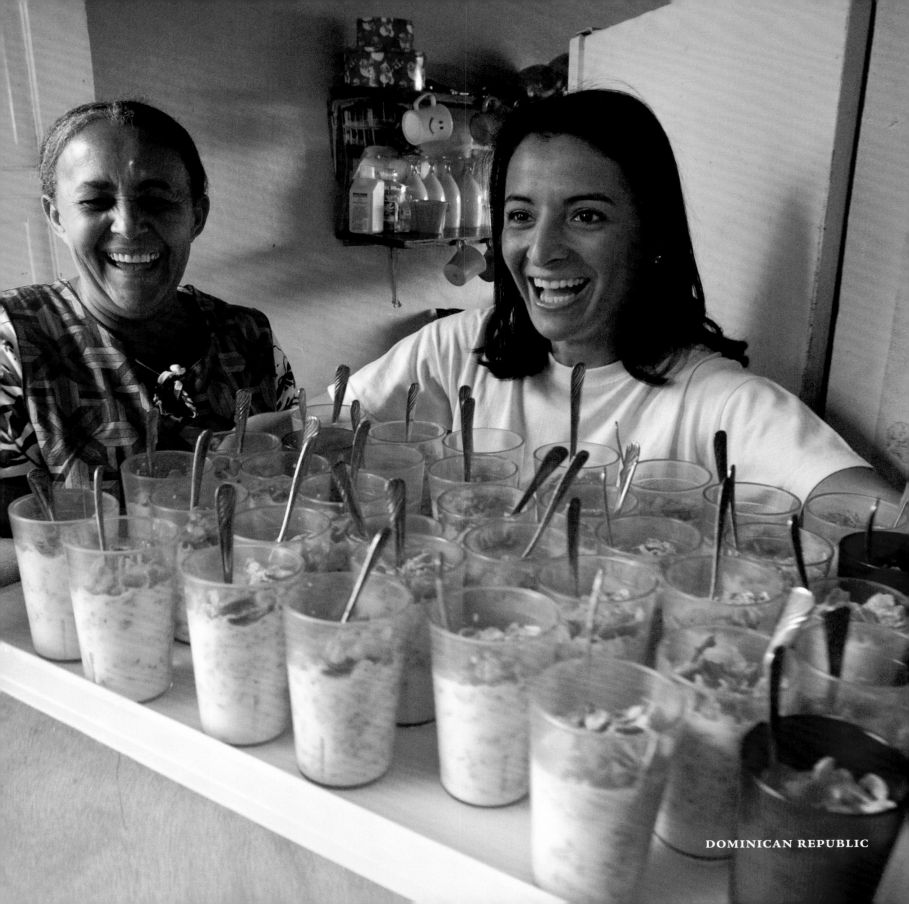

DOMINICAN REPUBLIC

ARGENTINA

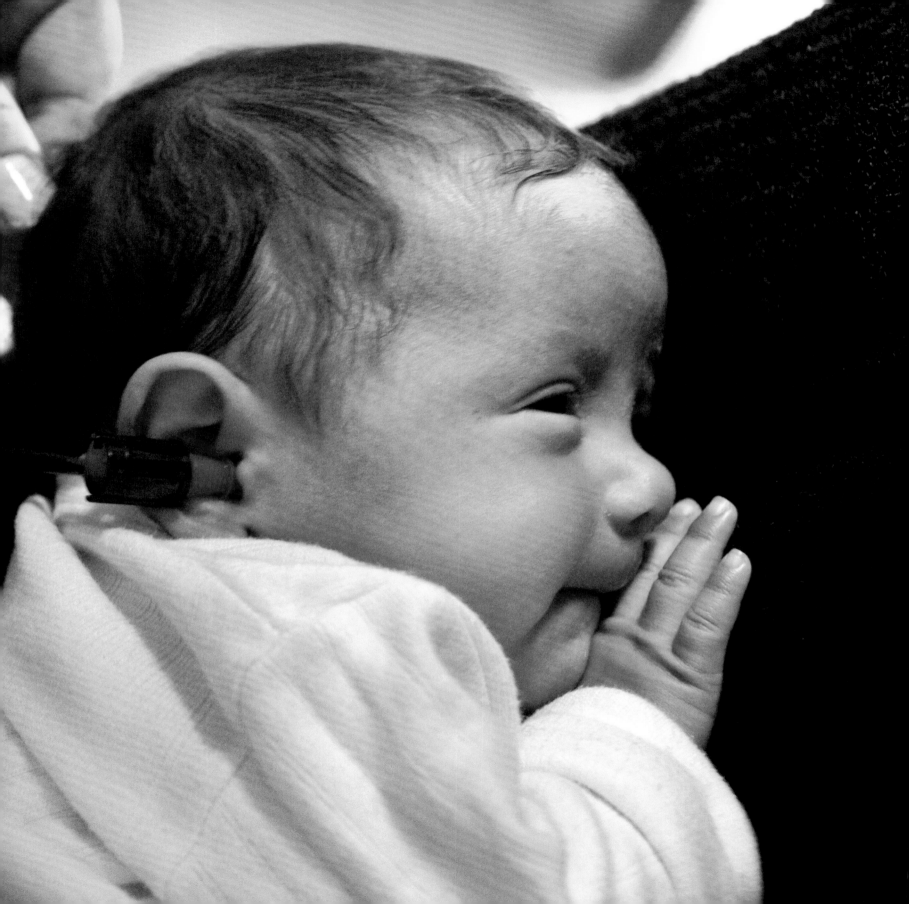

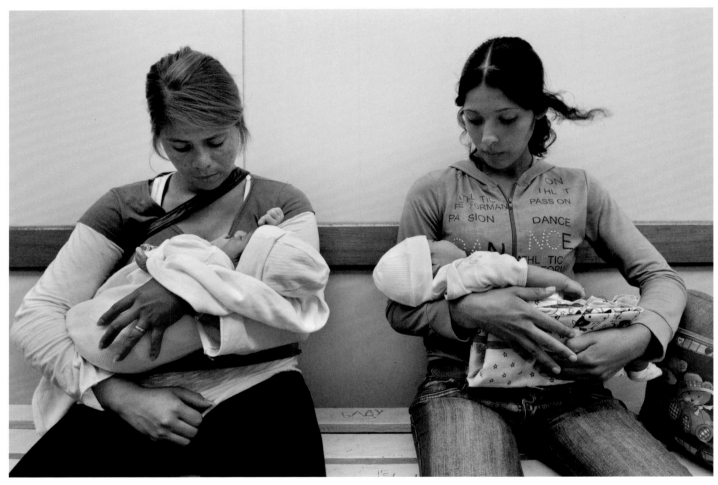

ARGENTINA

HONDURAS

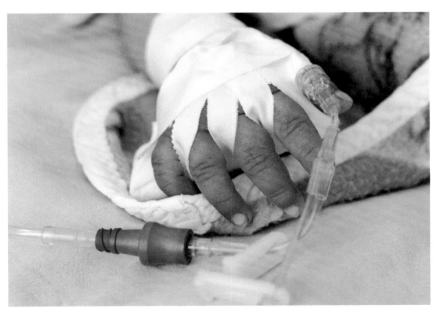

GUATEMALA

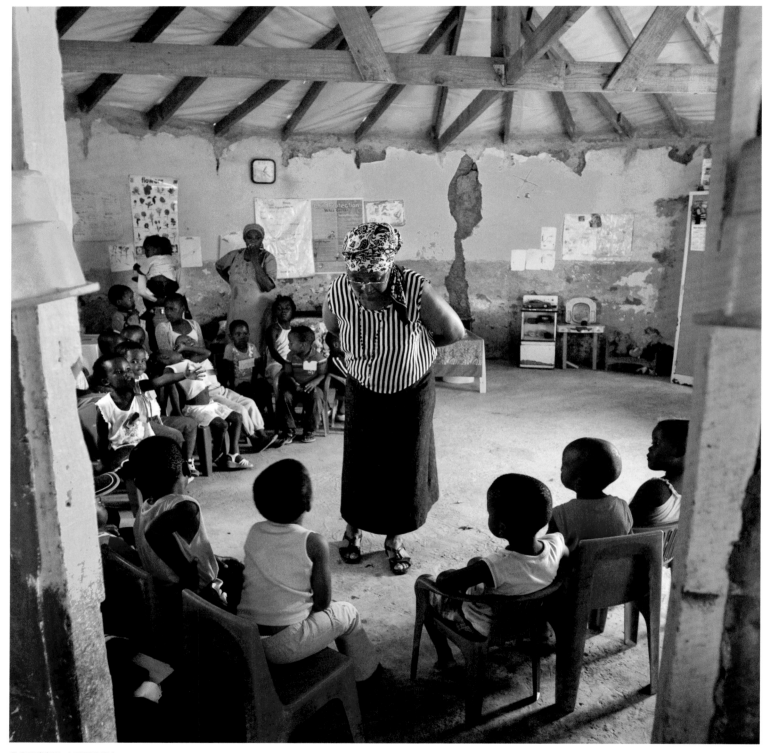

SOUTH AFRICA

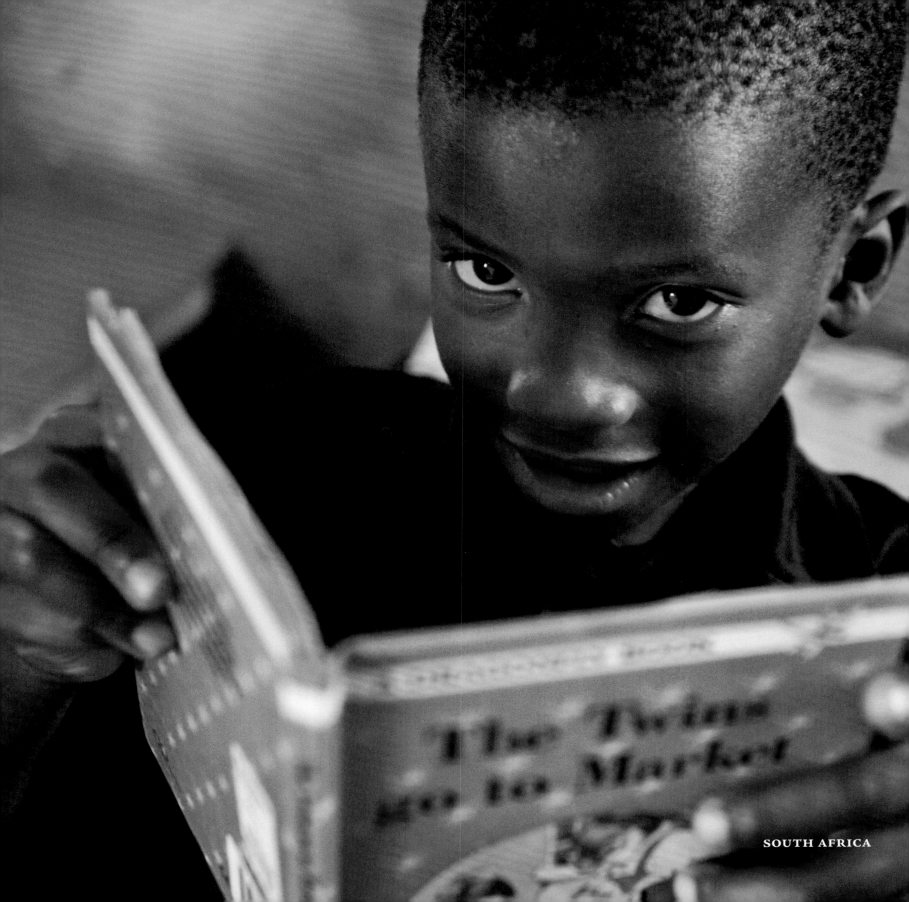

SOUTH AFRICA

ROMANIA

ROMANIA

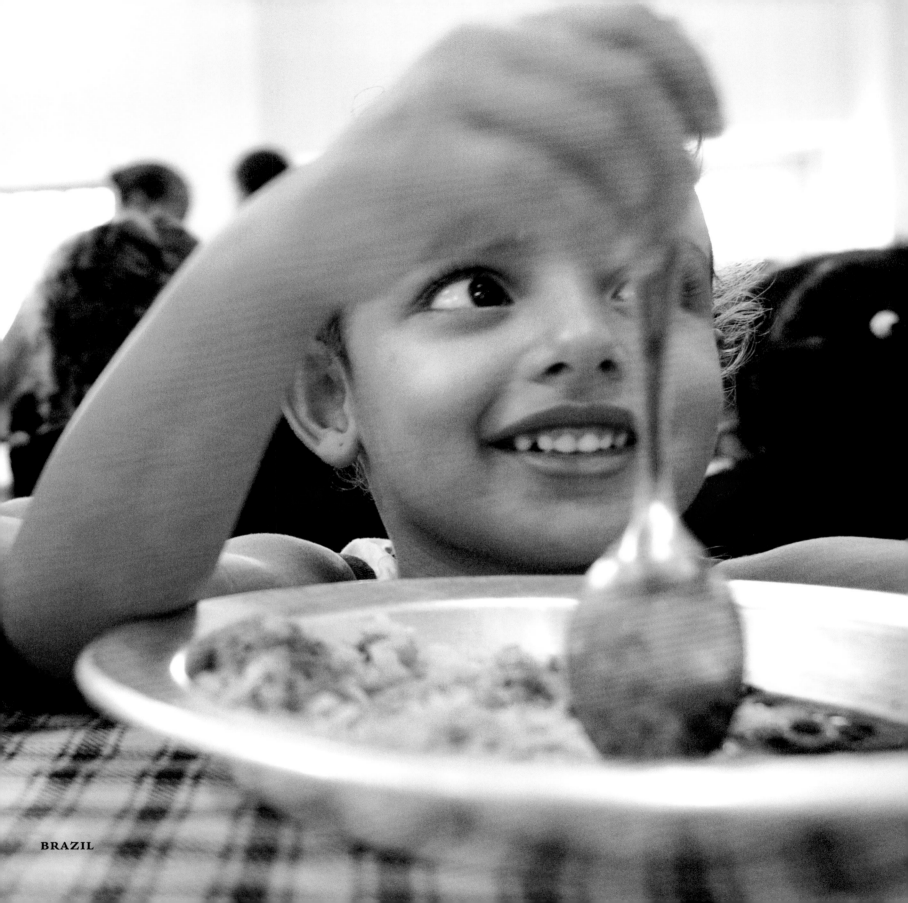

BRAZIL

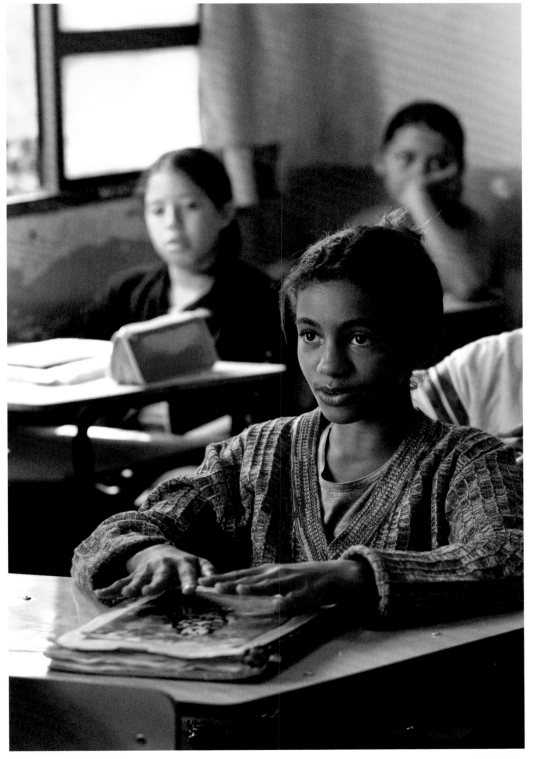

BRAZIL

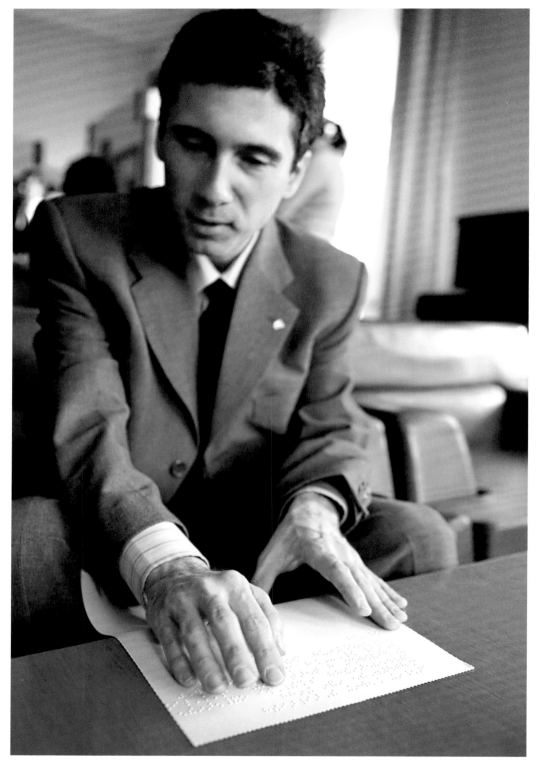

TURKEY

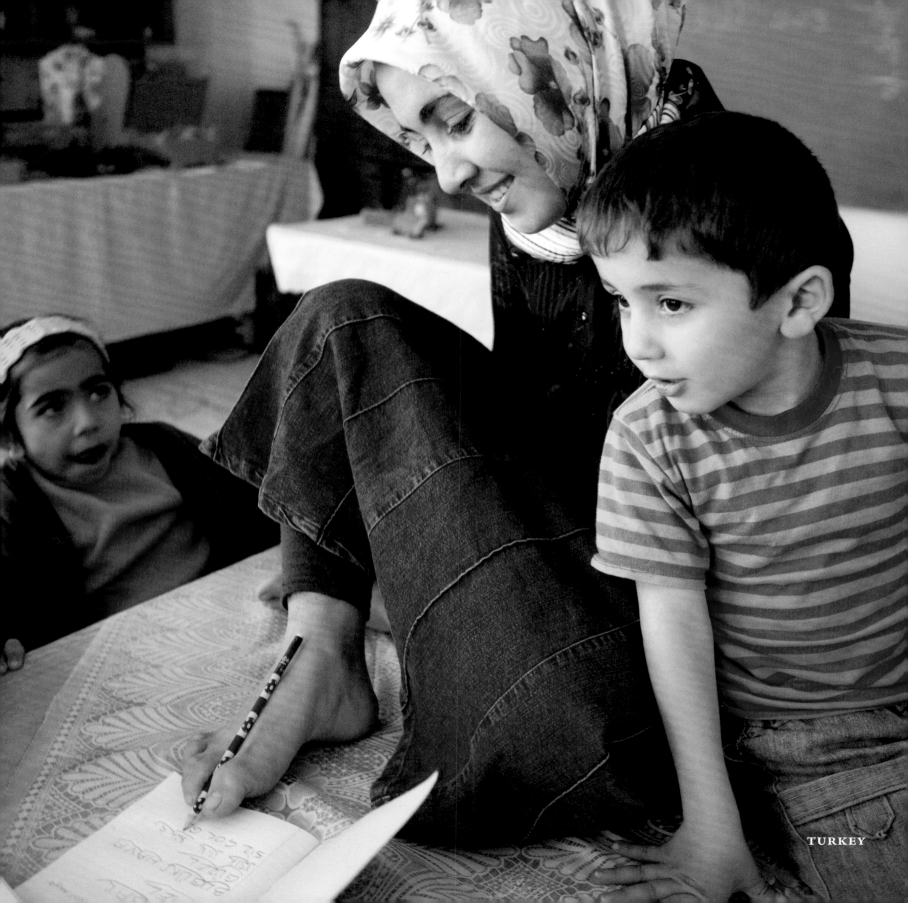

TURKEY

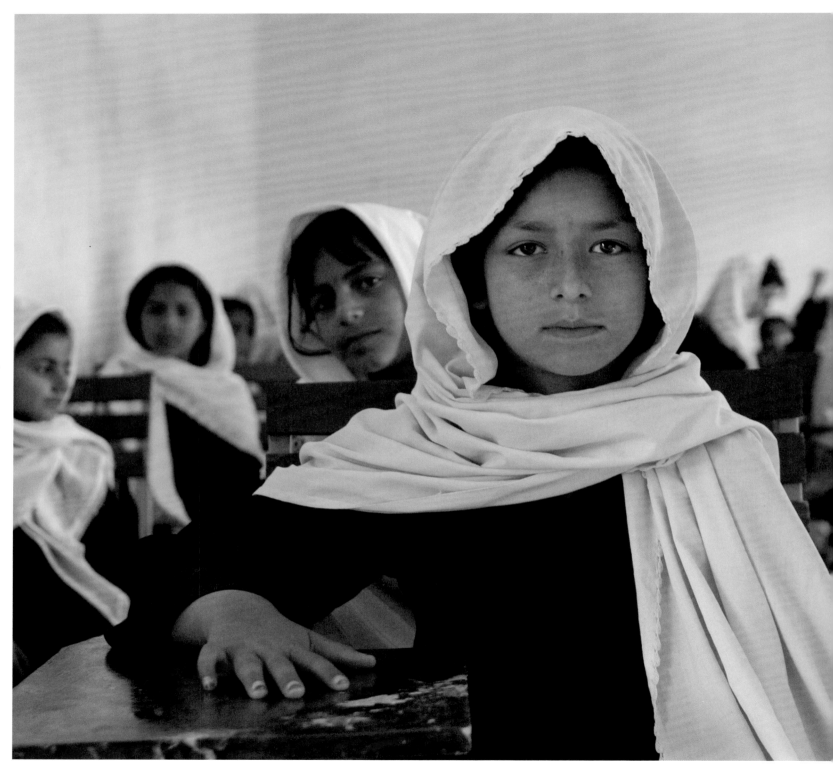

AFGHANISTAN

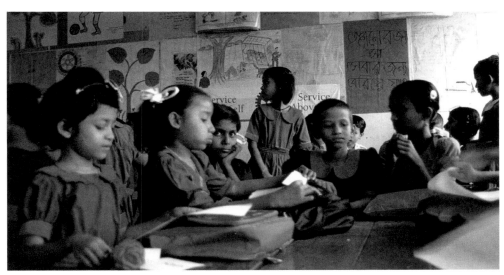

BANGLADESH

INDIA

INDIA

FRANCE

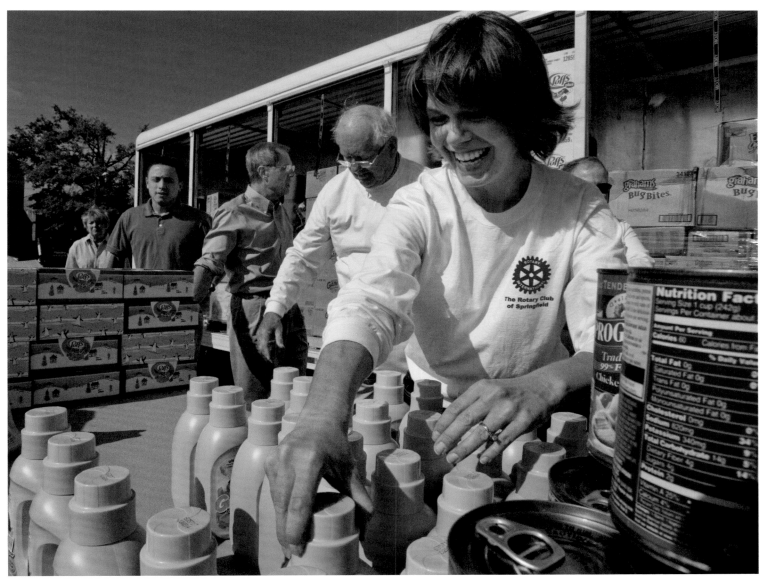

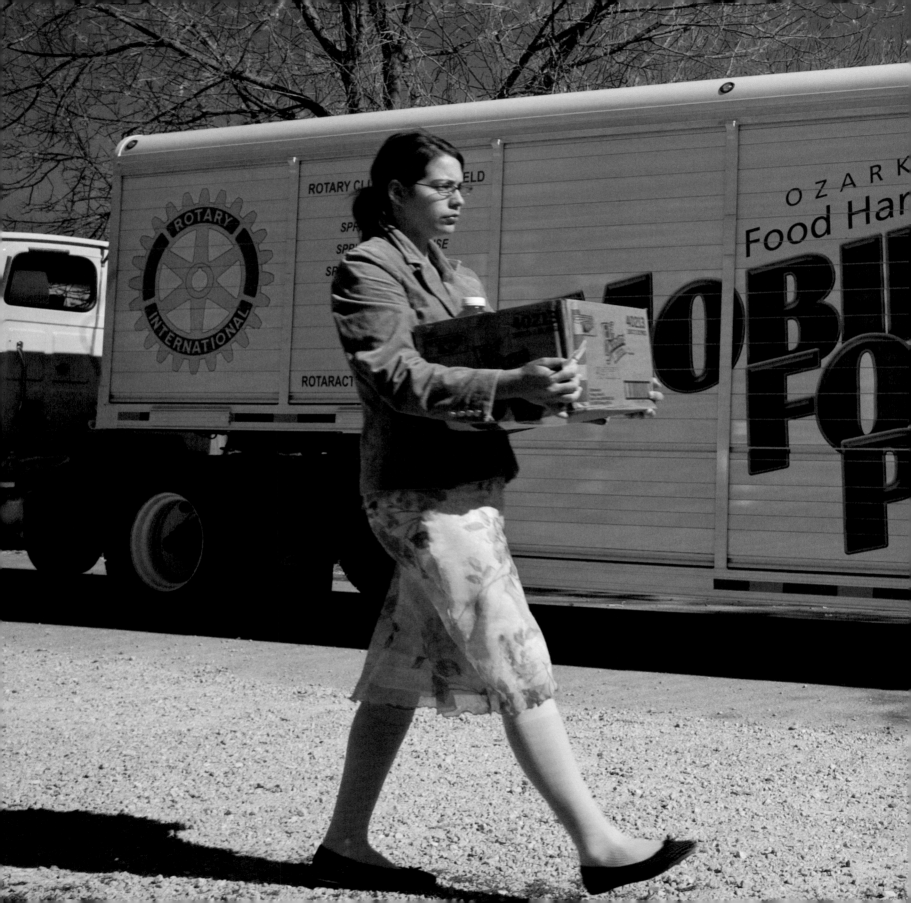

UNITED STATES

Providing clean water, sanitation facilities, and hygiene education

Agua potable, instalaciones sanitarias e higiene

Eau, assainissement et éducation à l'hygiène

きれいな水・公衆衛生施設や衛生教育をかなえる

깨끗한 물과 위생 시설의 제공

Fornecendo água potável, saneamento e educação em higiene básica

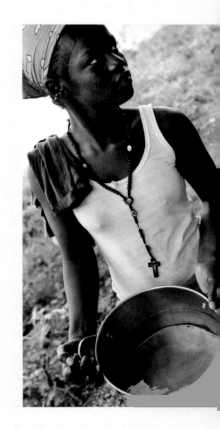

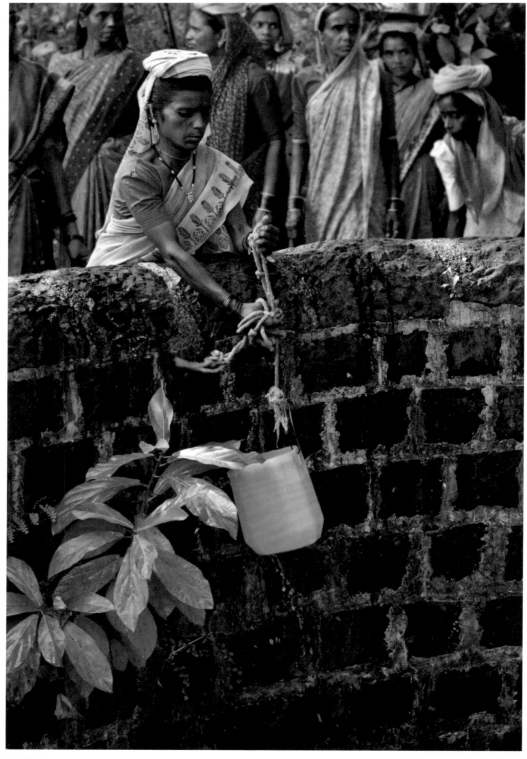

INDIA

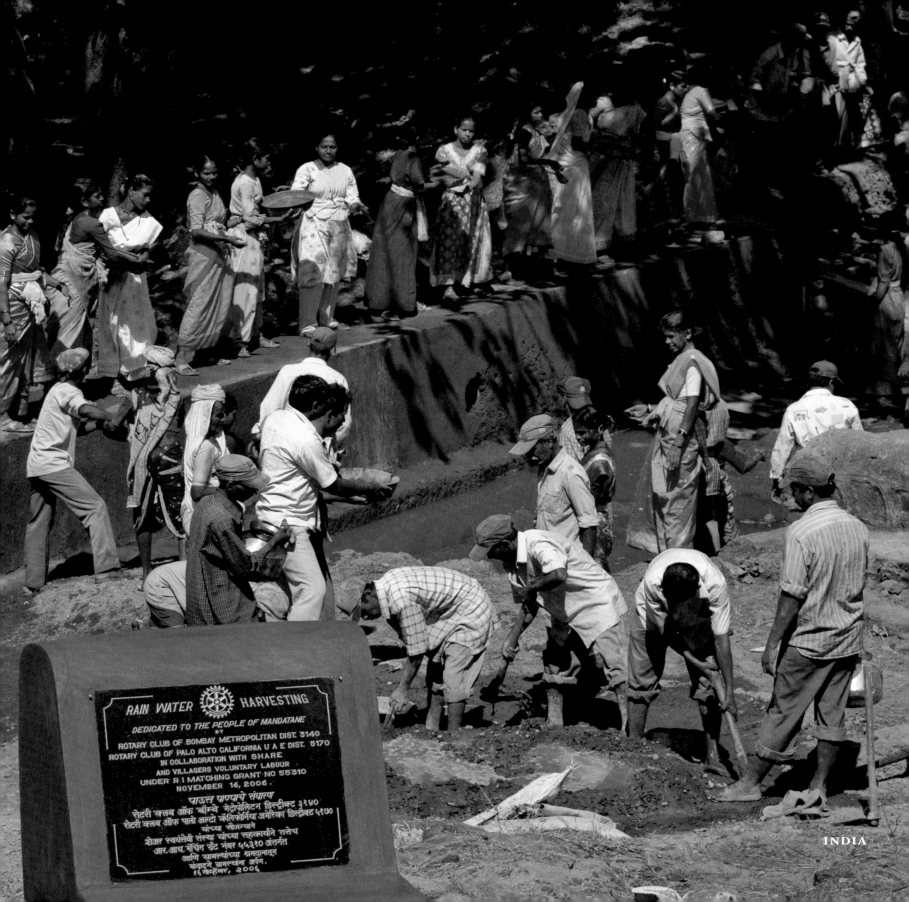

RAIN WATER ✦ HARVESTING

DEDICATED TO THE PEOPLE OF MANDATANE
BY
ROTARY CLUB OF BOMBAY METROPOLITAN DIST. 3140
ROTARY CLUB OF PALO ALTO CALIFORNIA U A E DIST. 5170
IN COLLABORATION WITH SHARE
AND VILLAGERS VOLUNTARY LABOUR
UNDER R I MATCHING GRANT NO 55310
NOVEMBER 16, 2006.

पाऊस पाण्याचे संधारण
रोटरी क्लब ऑफ बॉम्बे मेट्रोपॉलिटन डिस्ट्रीक्ट ३१४०
रोटरी क्लब ऑफ पालो अल्टो कॅलिफोर्निया अमेरिका डिस्ट्रीक्ट ५१७०
यांच्या योजनेने
शेअर स्वयंसेवी संस्था यांच्या सहकार्याने तसेच
आर.आय. मॅचिंग ग्रँट नंबर ५५३१० अंतर्गत
आणि ग्रामस्थांच्या श्रमदानातून
मंदातने आपलधना अंग.
१६ नोव्हेंबर, २००६.

INDIA

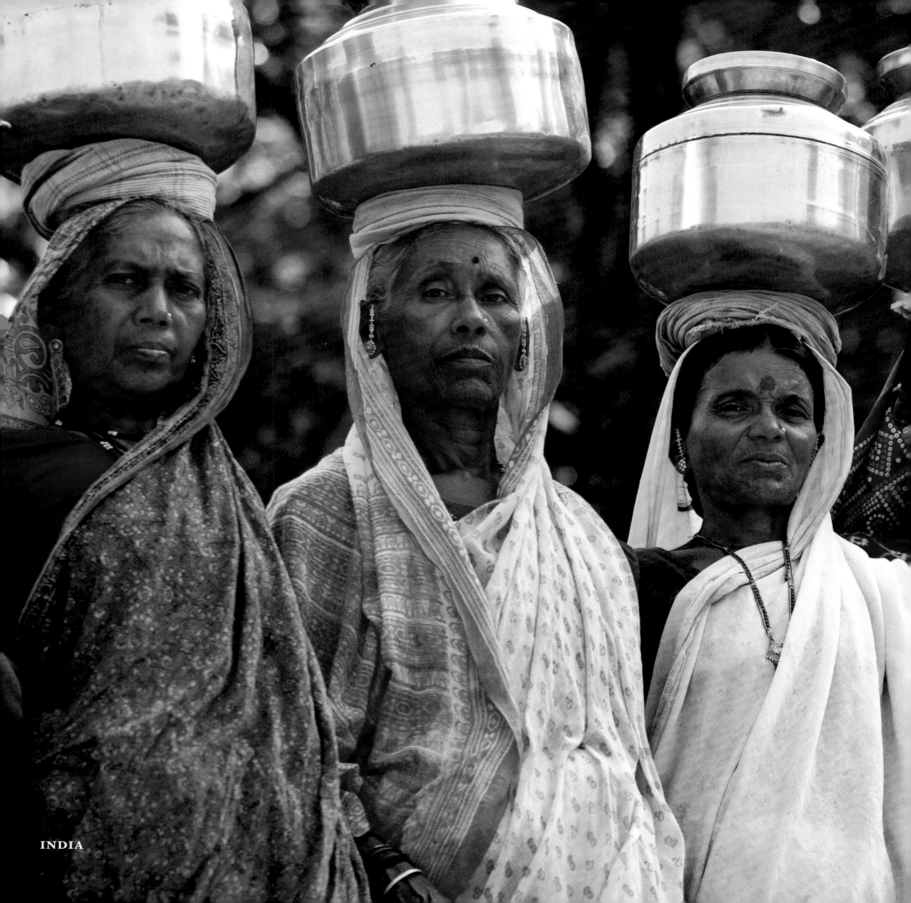

INDIA

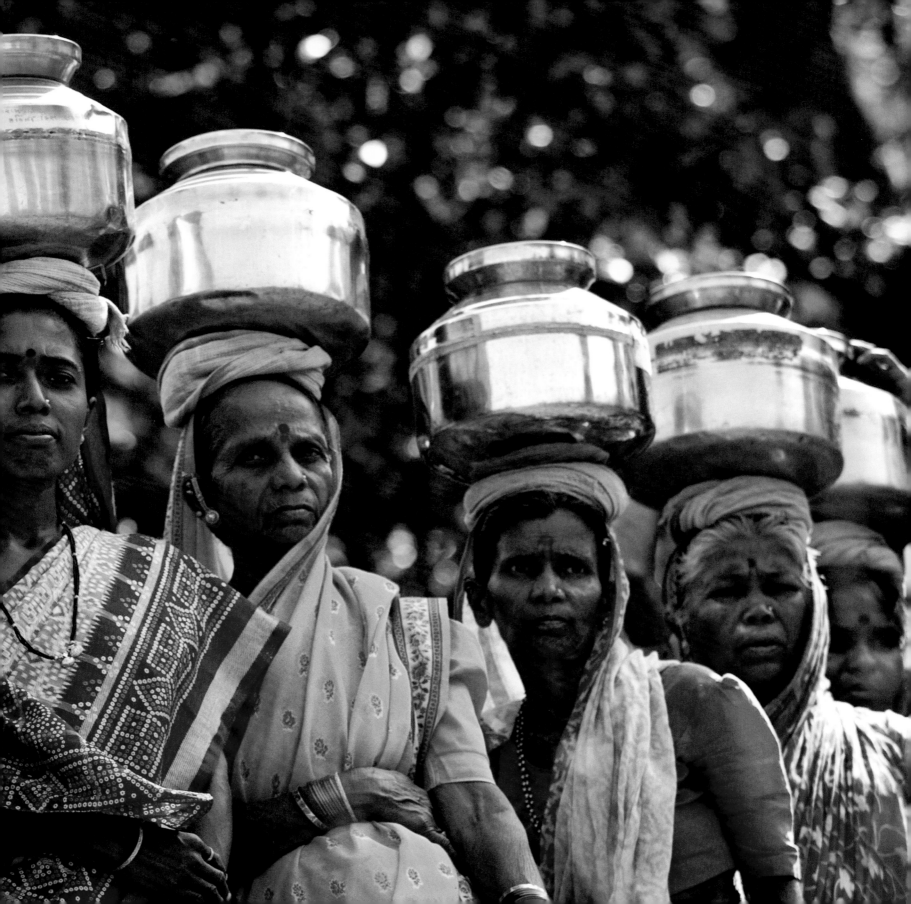

DOMINICAN REPUBLIC

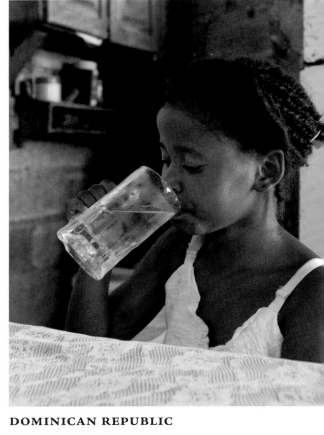

DOMINICAN REPUBLIC

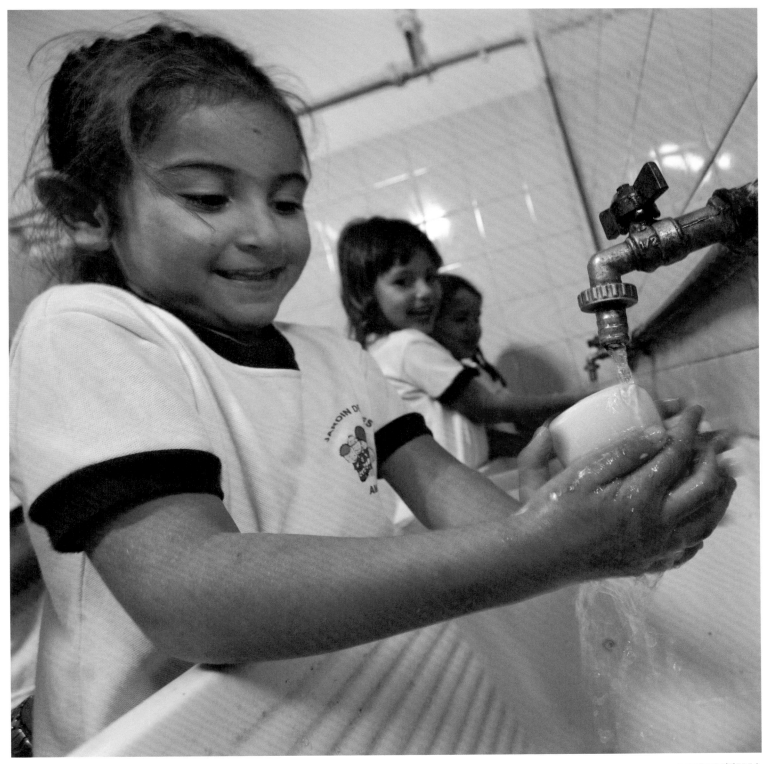

ARGENTINA

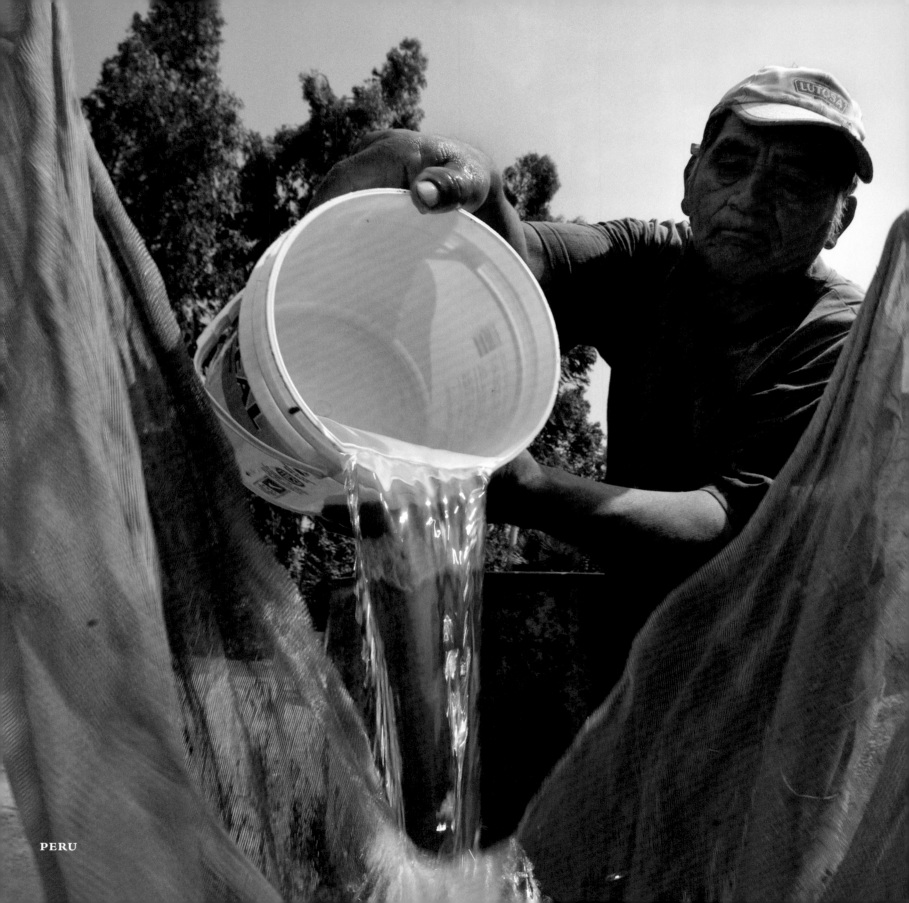

PERU

PERU

PERU

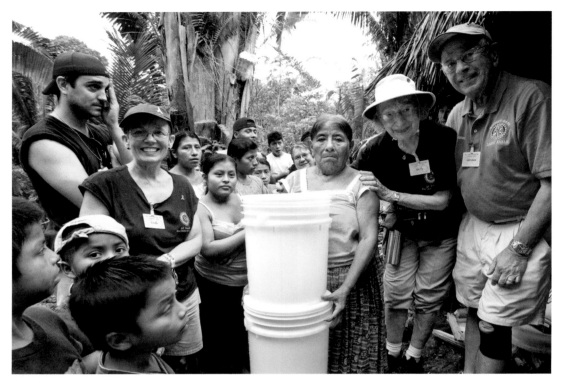

GUATEMALA

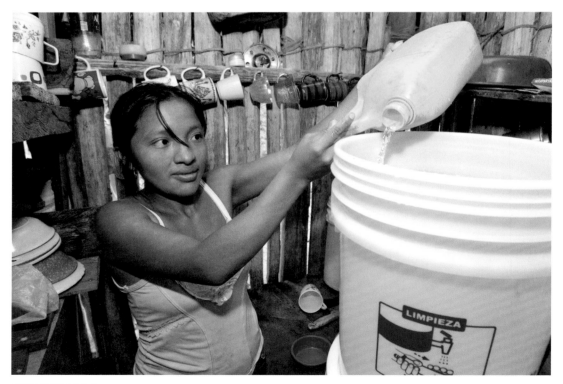

GUATEMALA

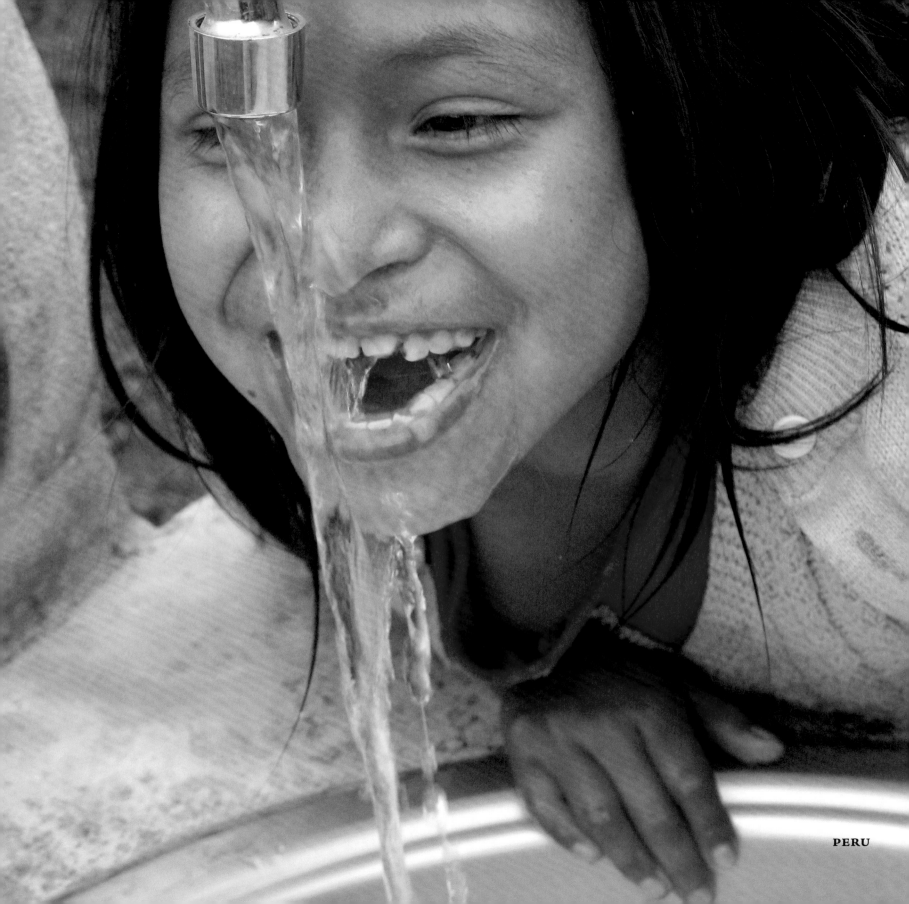

PERU

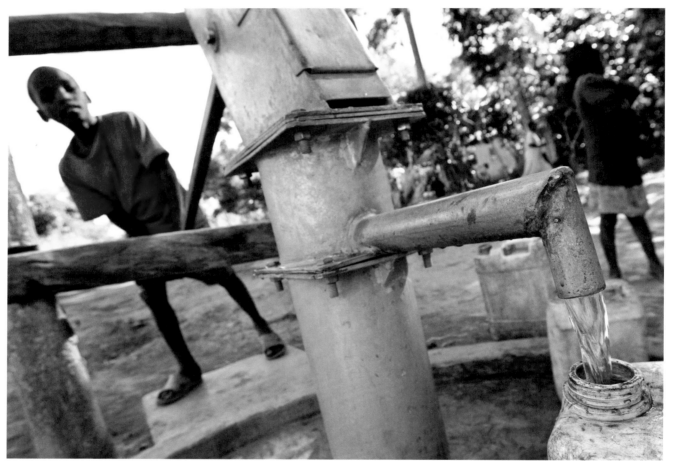

UGANDA

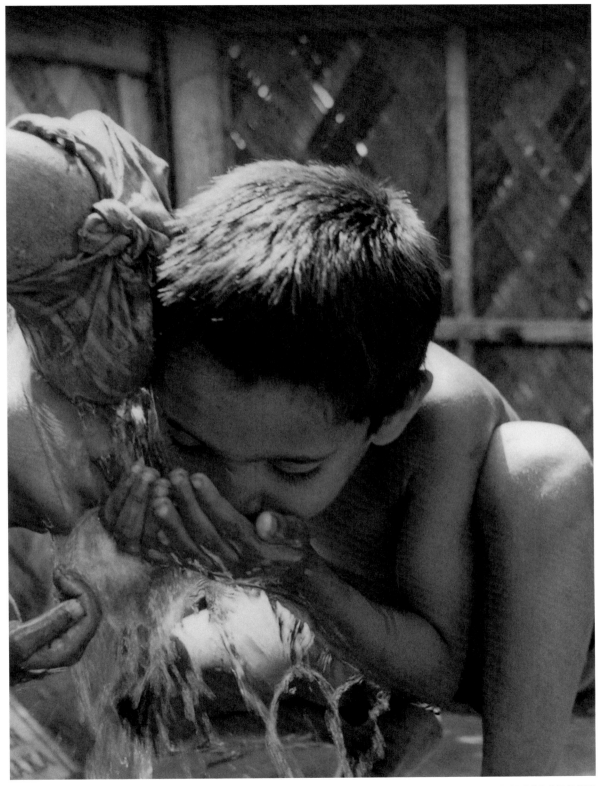

BANGLADESH

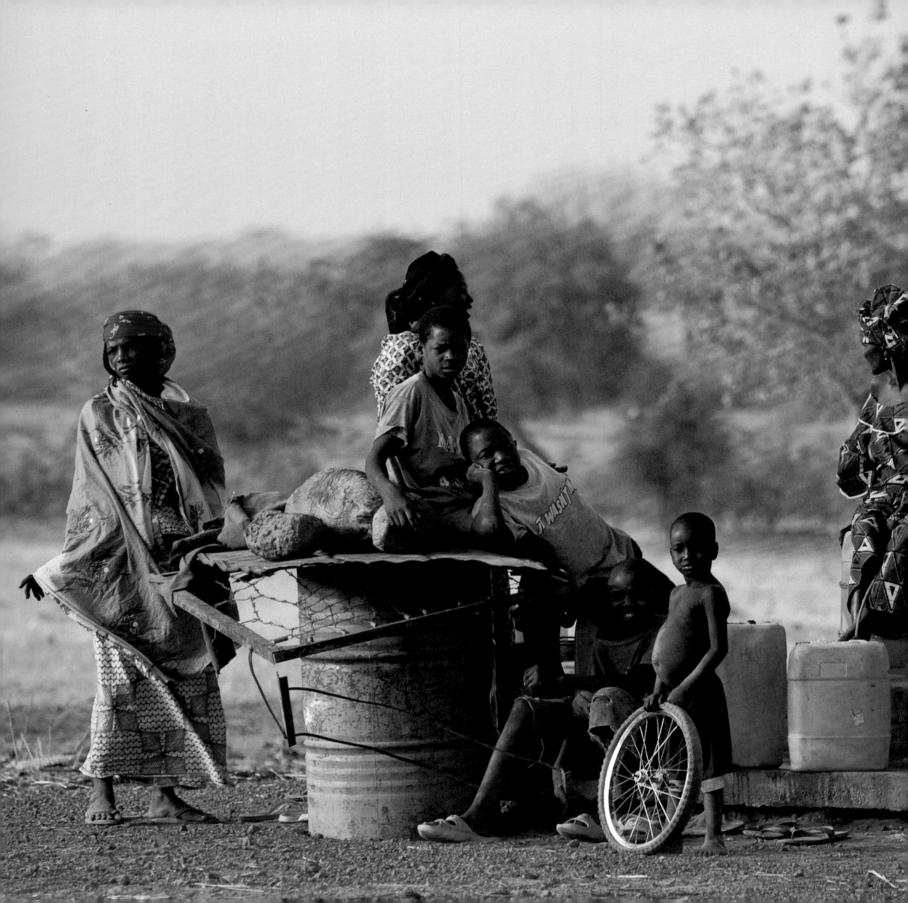

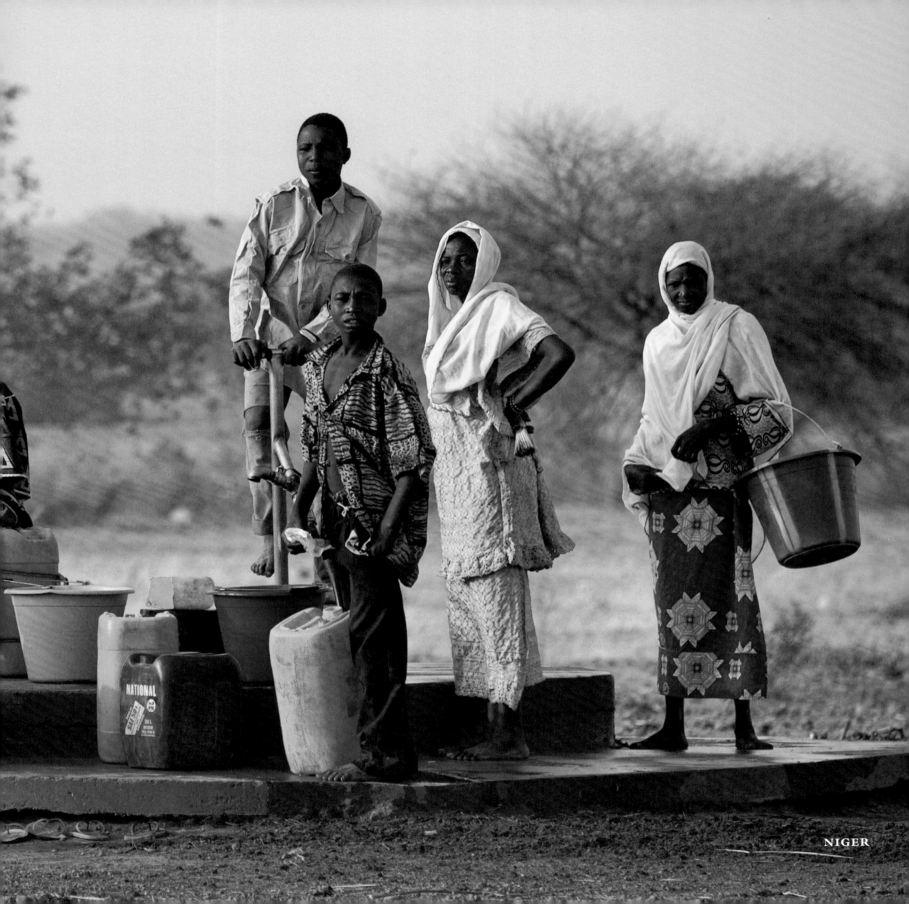

NIGER

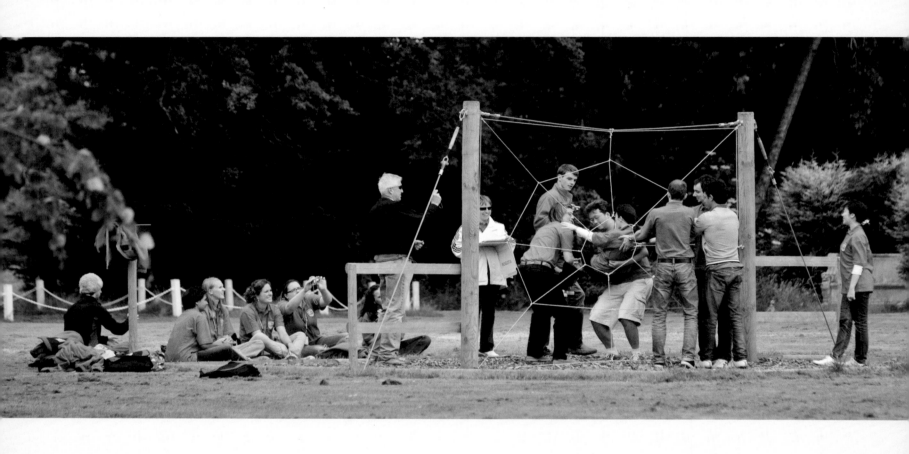

Helping young people develop valuable skills

Los jóvenes adquieren destrezas valiosas

Développement professionnel des jeunes

青少年に価値ある教育を

청소년들에게 삶의 기술을 가르치다

Ajudando jovens a desenvolver capacidades valiosas

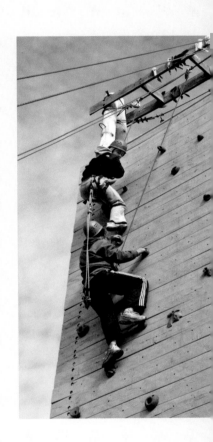

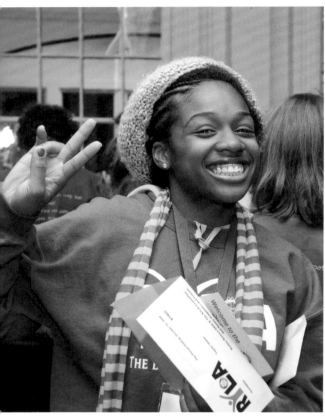

UNITED STATES

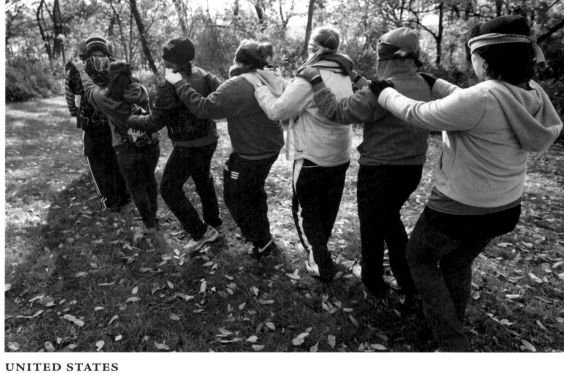

UNITED STATES

SWEDEN

CANADA

FRANCE

FRANCE

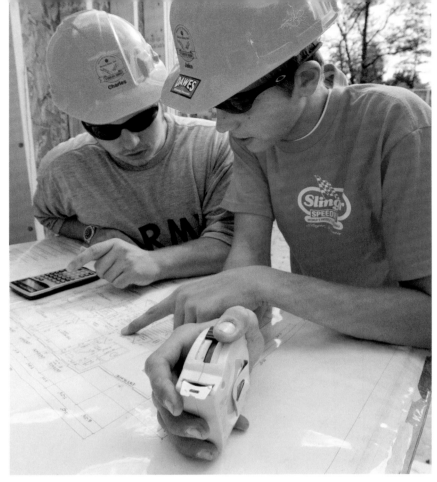

UNITED STATES

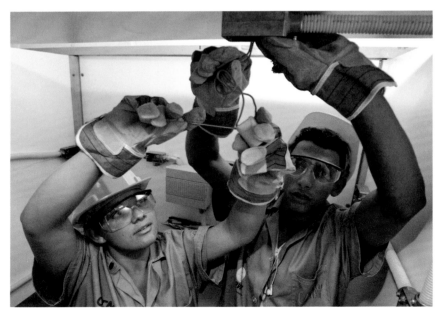

BRAZIL

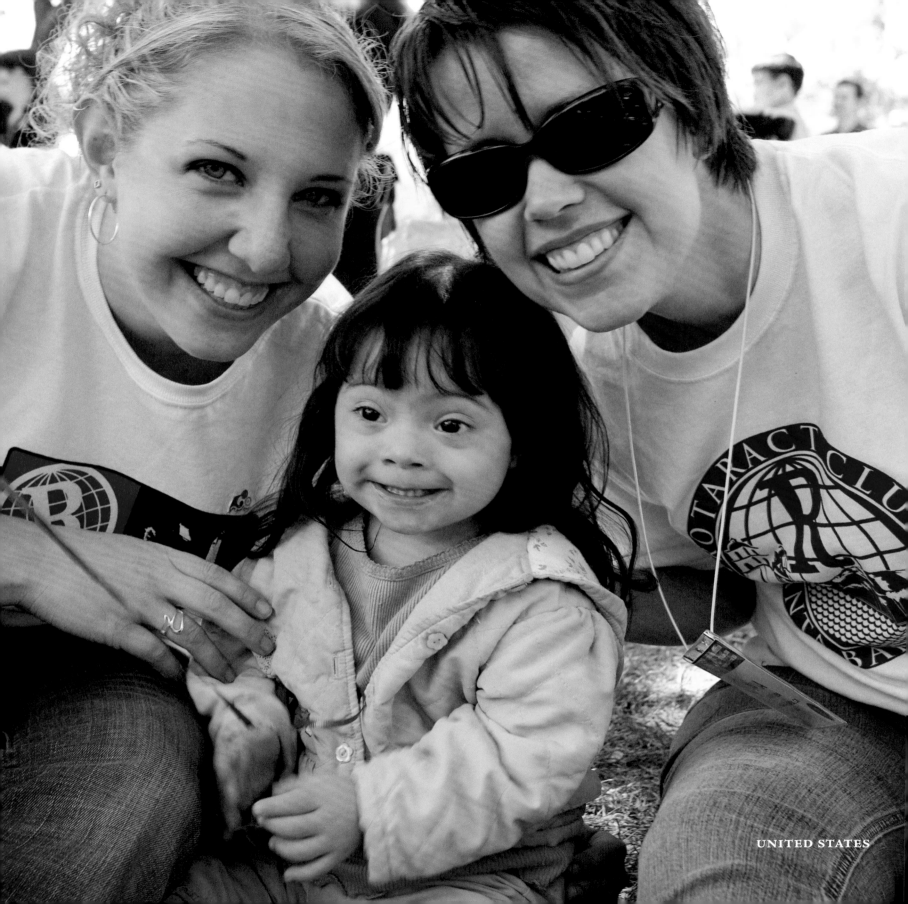

UNITED STATES

Responding and rebuilding after disaster strikes

Respuesta y reconstrucción en casos de desastre

Aide d'urgence en cas de catastrophe et reconstruction

災害に対応し、その後の再建を支える

자연재해 지역에 내미는 구호의 손길

Reconstruindo áreas atingidas por catástrofes

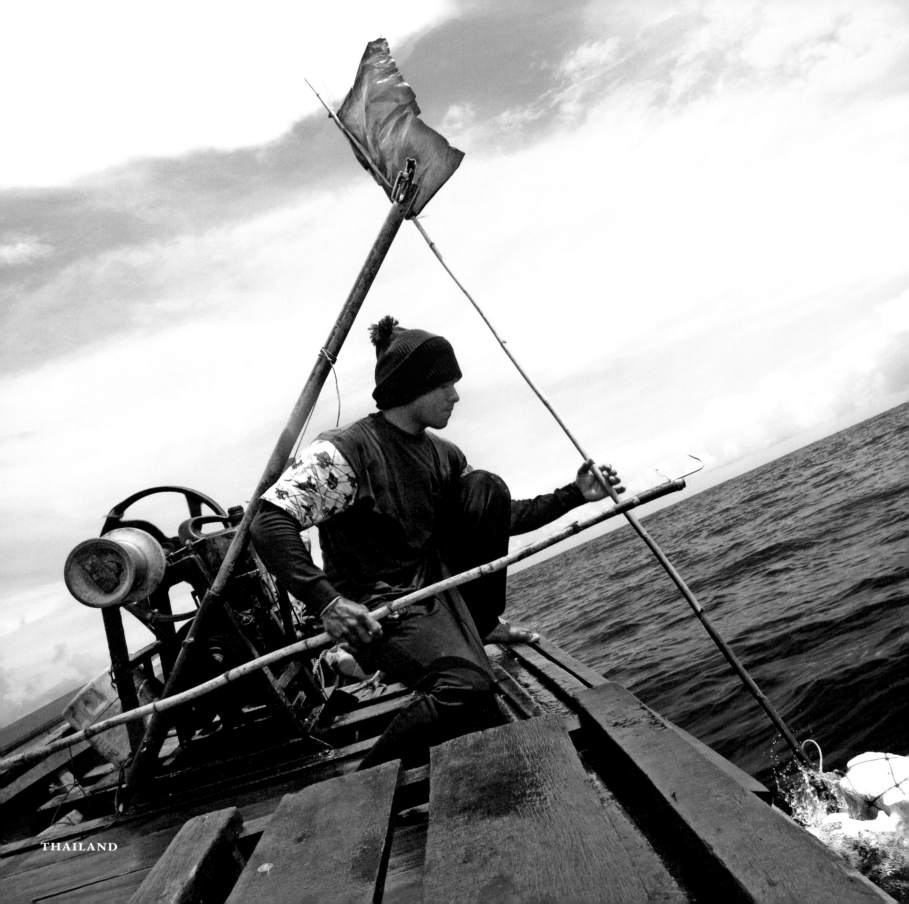

THAILAND

THAILAND

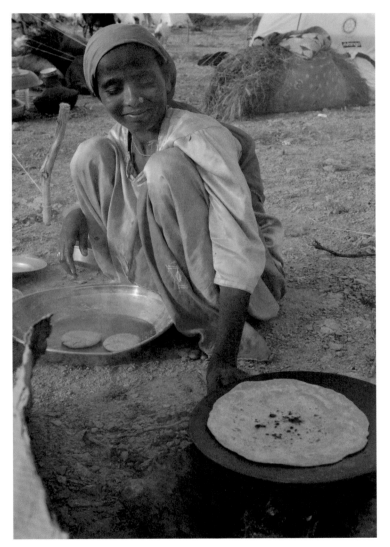

PAKISTAN

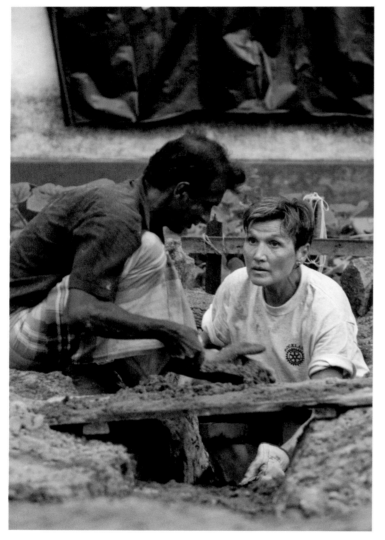

SRI LANKA

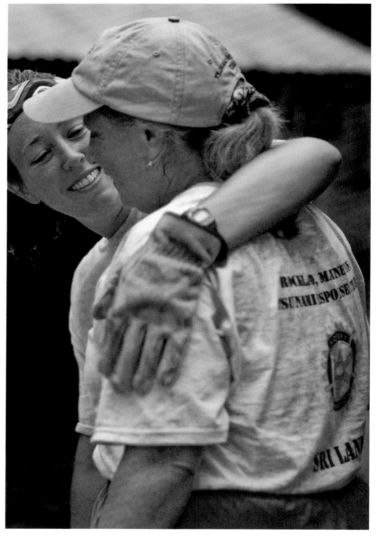

SRI LANKA

SRI LANKA

SRI LANKA

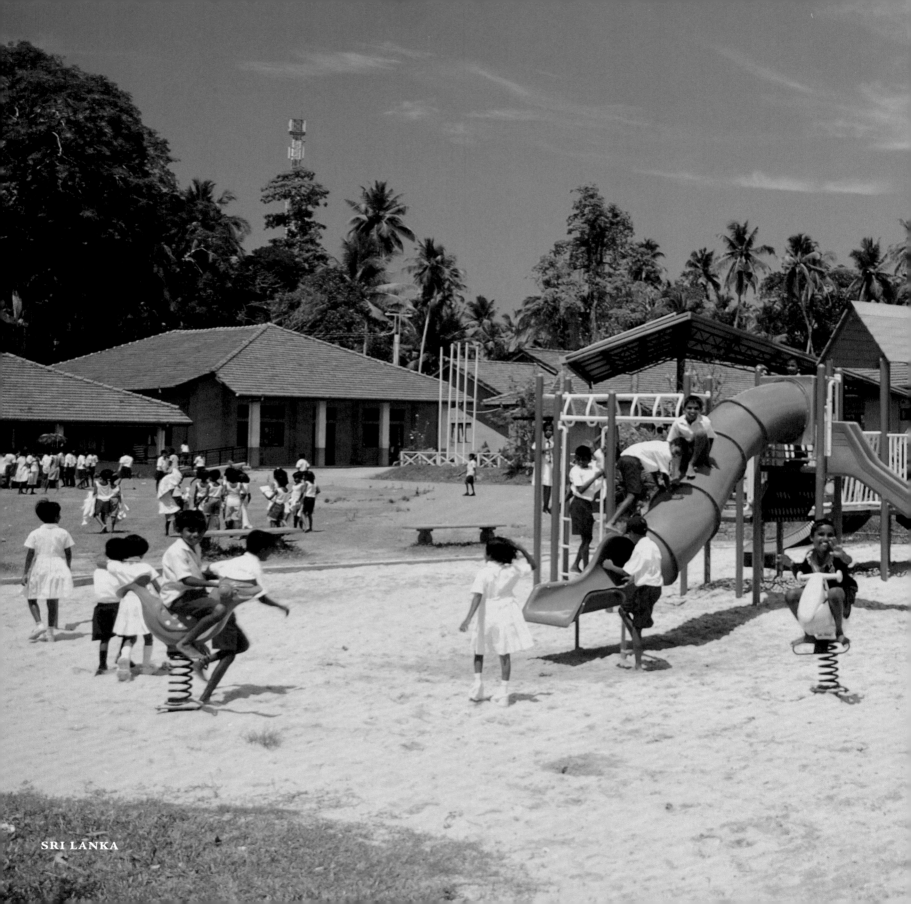

SRI LANKA

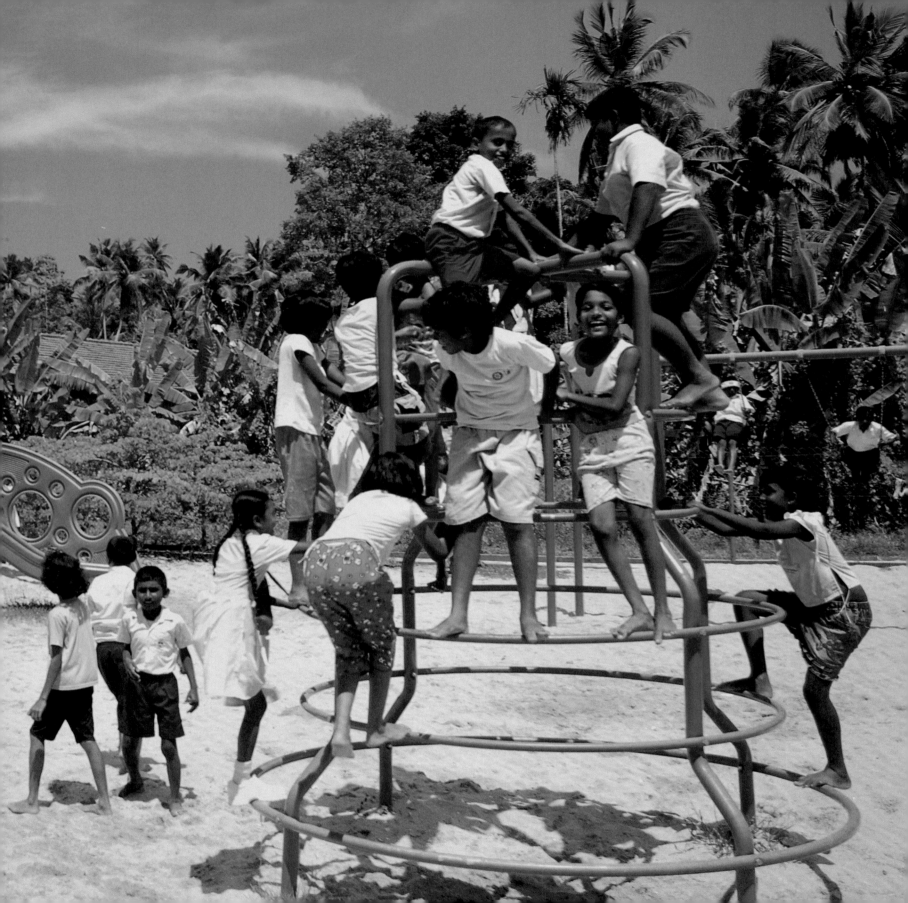

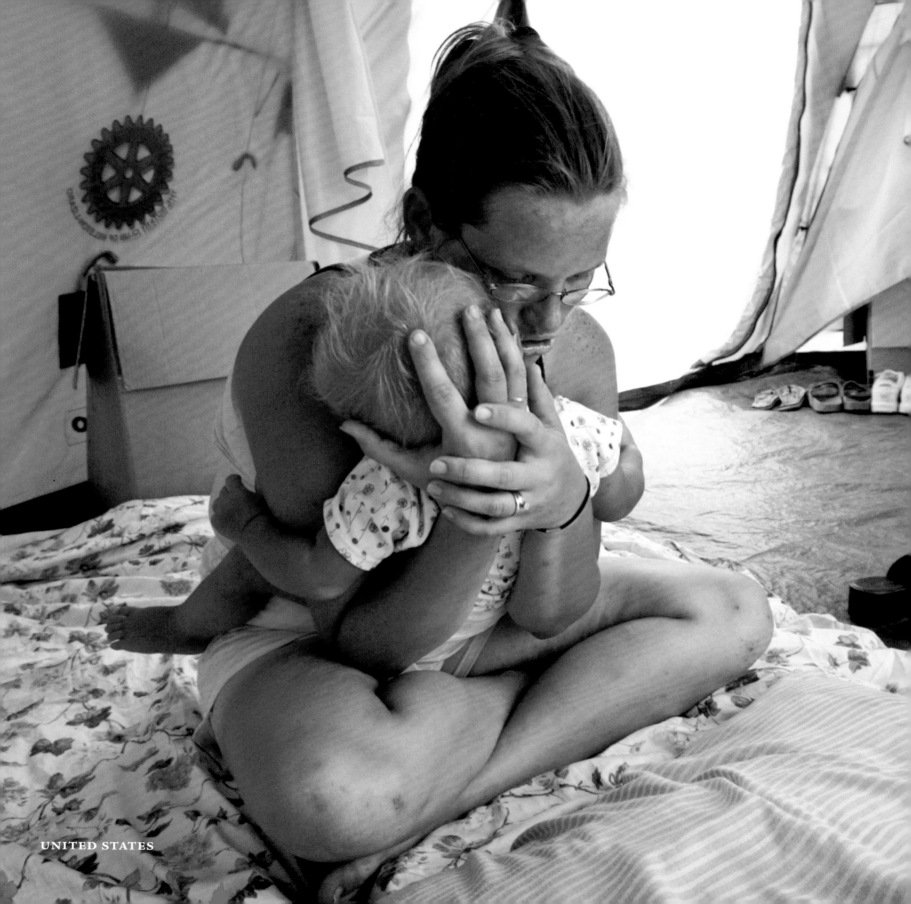

UNITED STATES

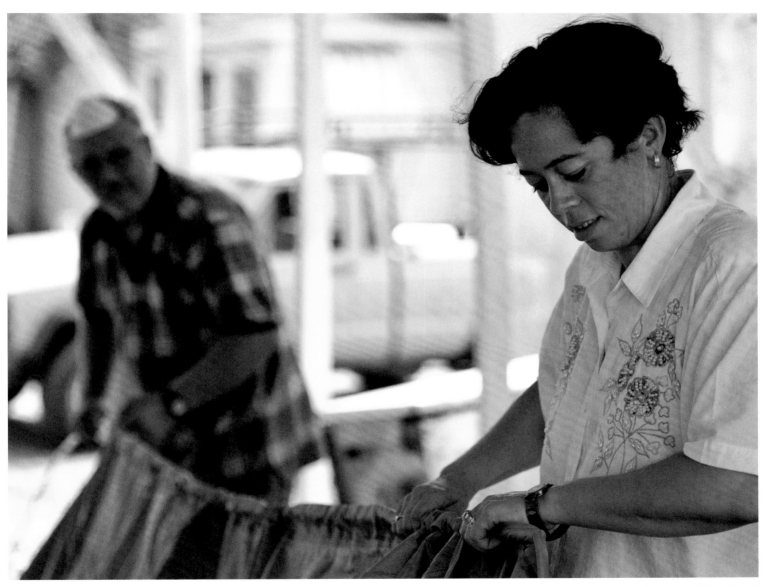

UNITED STATES

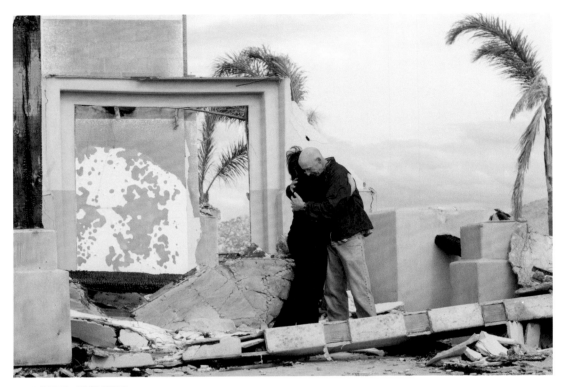

UNITED STATES

UNITED STATES

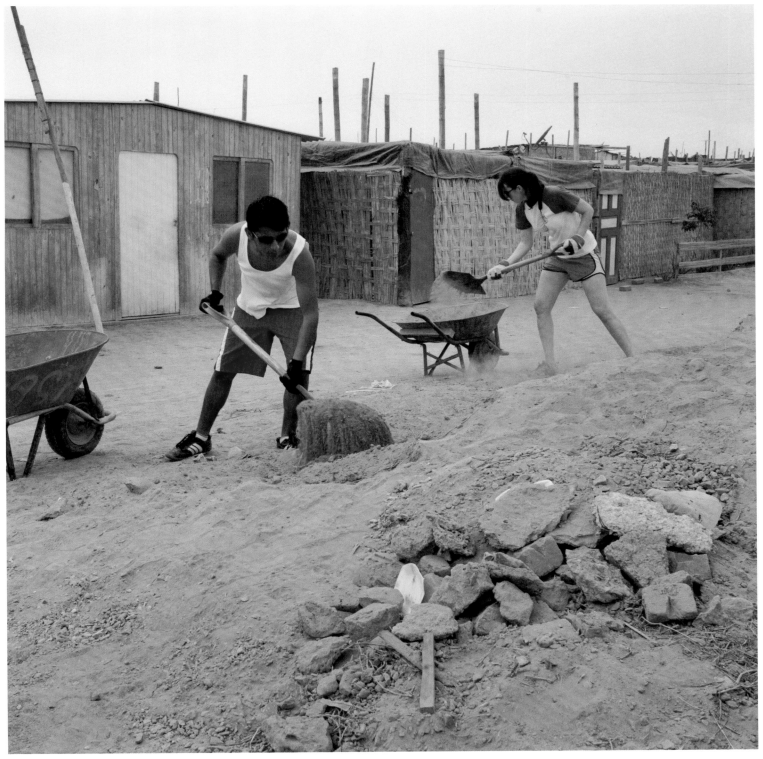

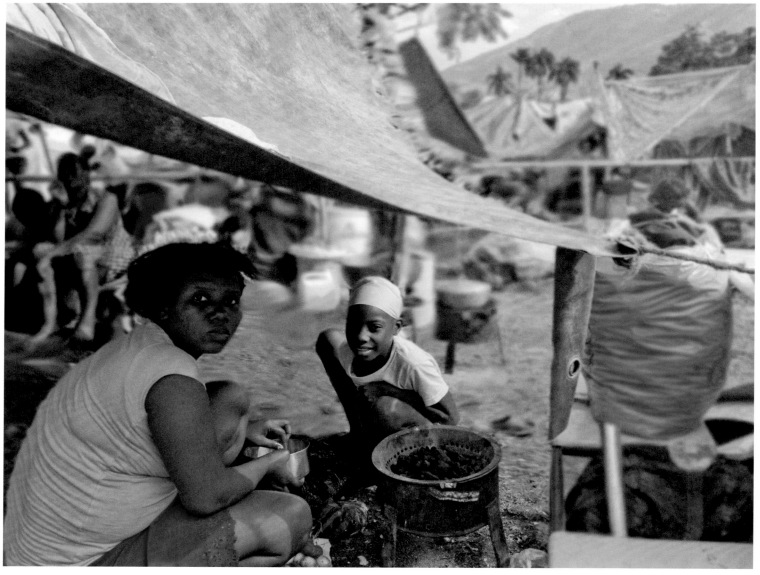

HAITI

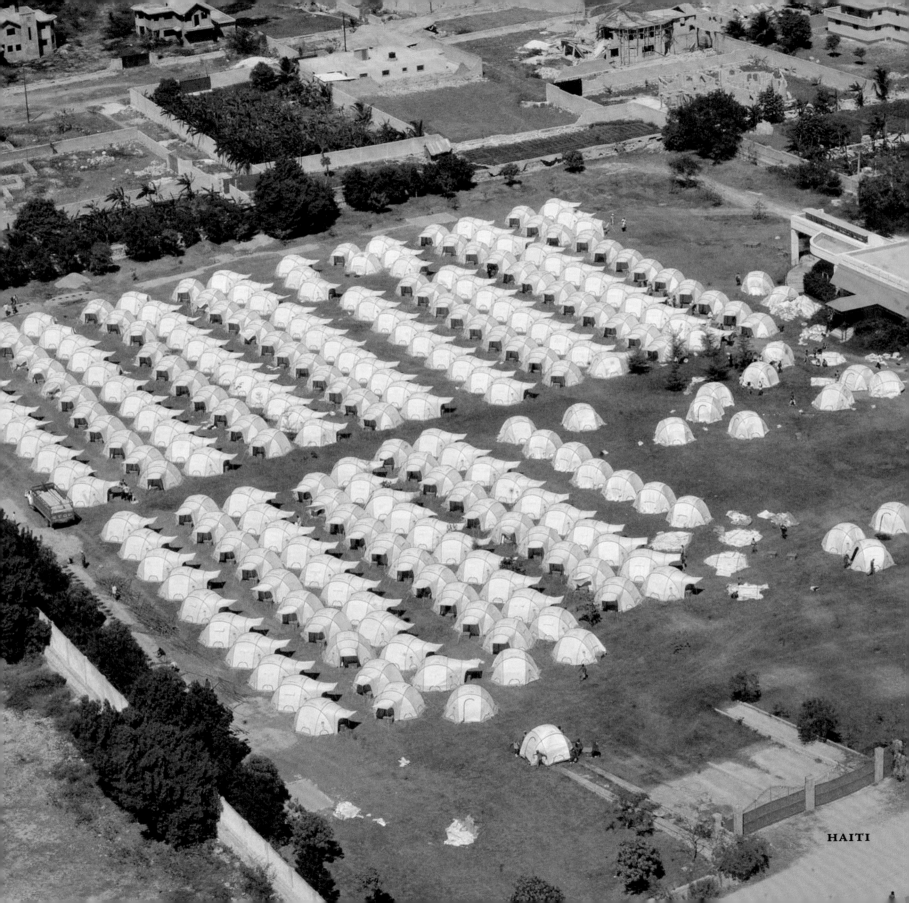

HAITI

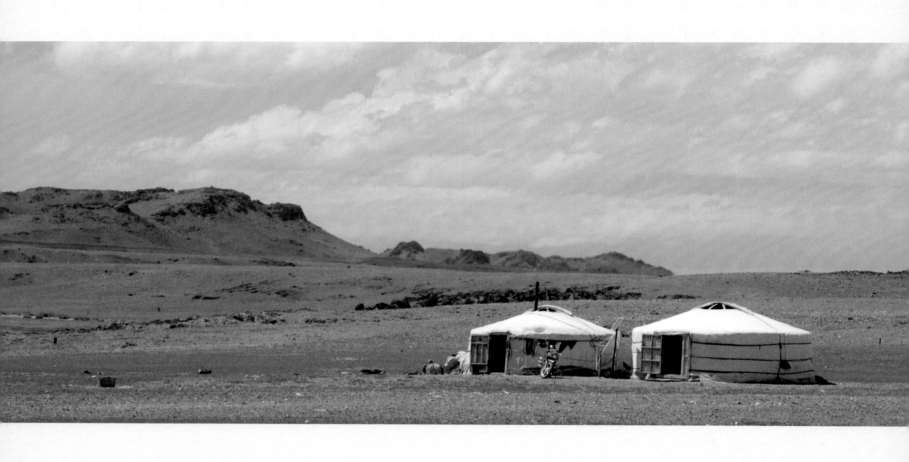

Preserving Planet Earth

Preservación del planeta tierra

Protection de l'environnement

地球を守るために

지구를 보전하라

Preservando o Planeta Terra

MONGOLIA

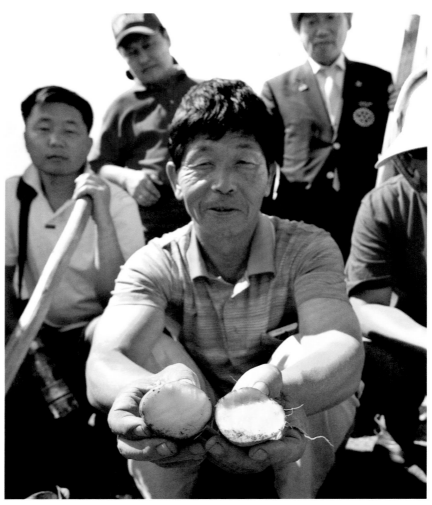

MONGOLIA

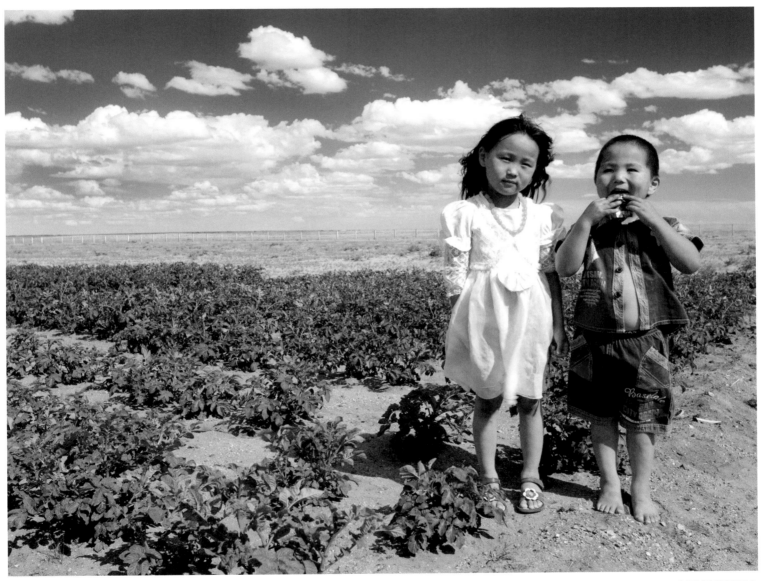

MONGOLIA

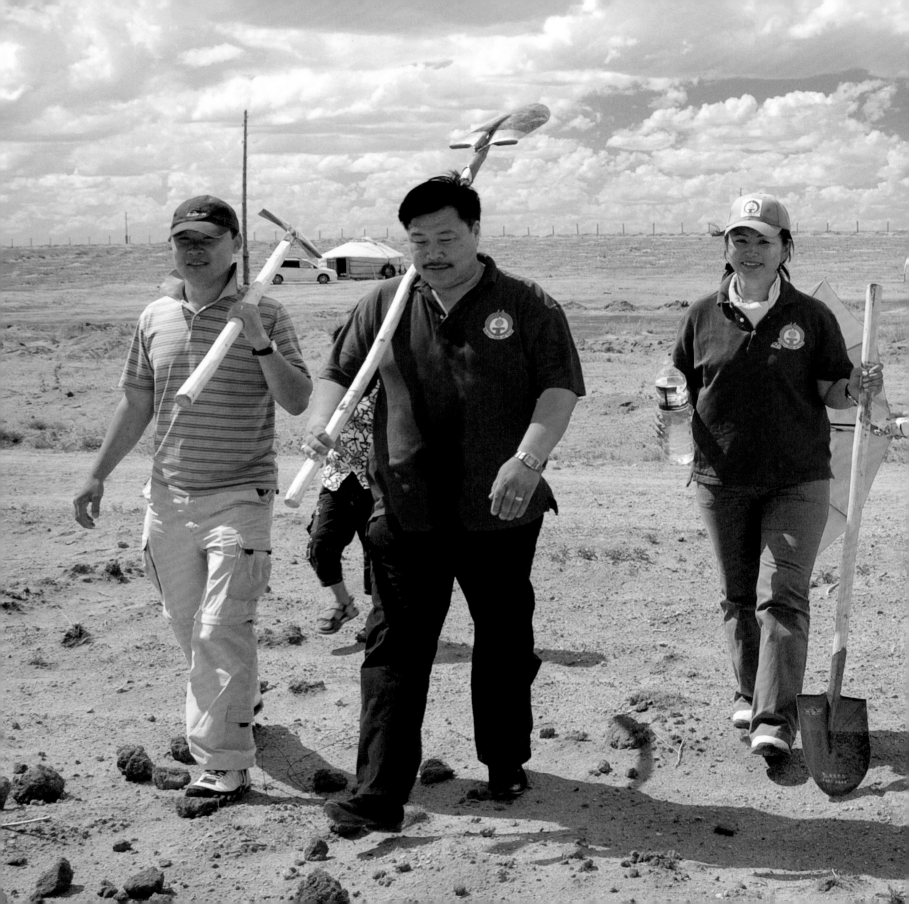

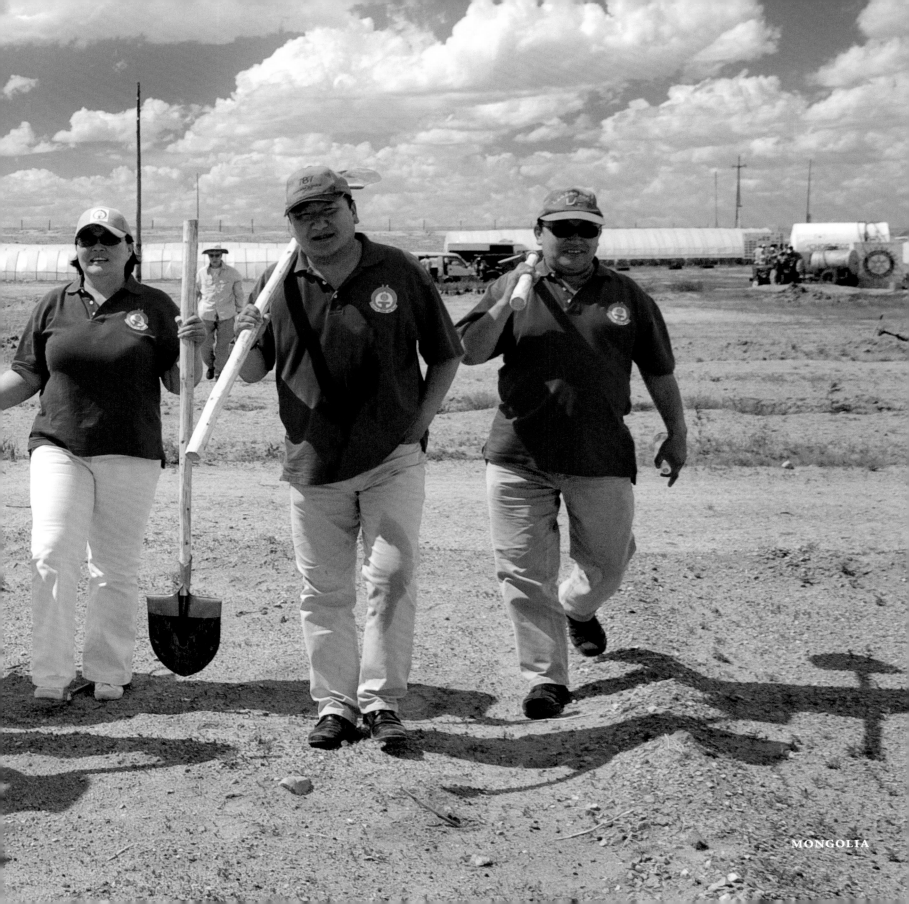

MONGOLIA

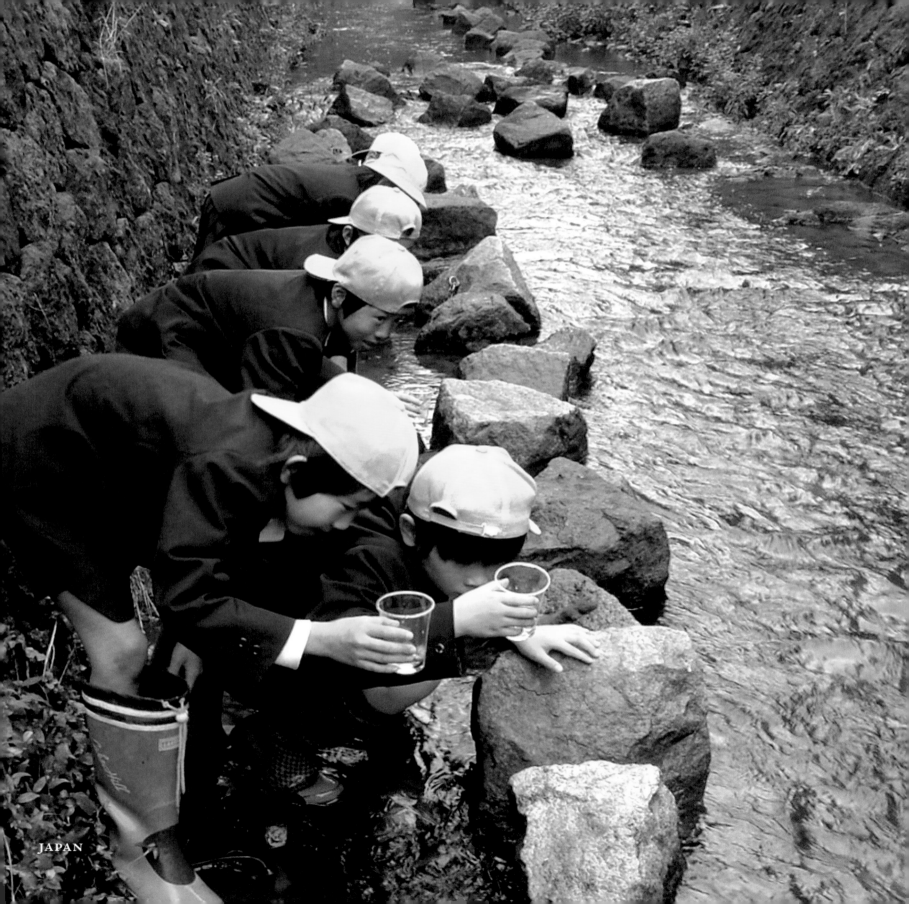

JAPAN

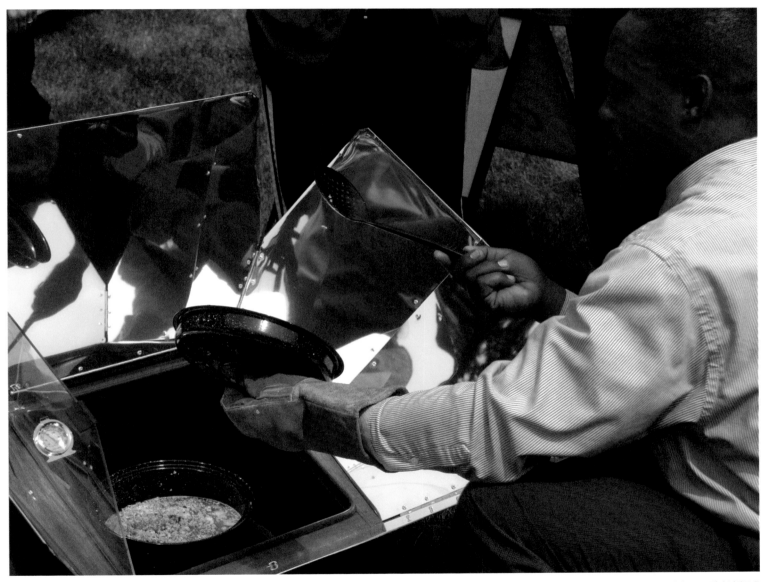

UNITED STATES

Supporting economic development

En pos del desarrollo económico

Soutien au développement économique

経済の発展を支援する

경제 개발 지원

Apoiando desenvolvimento econômico

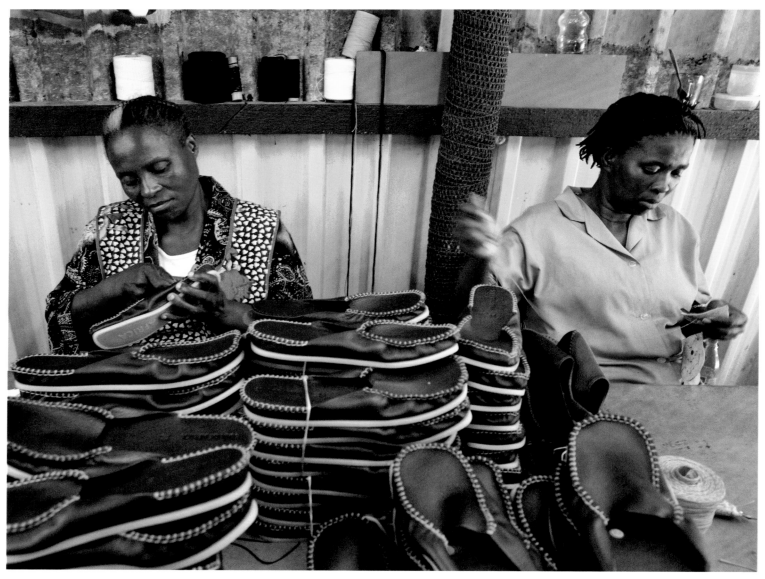

SOUTH AFRICA

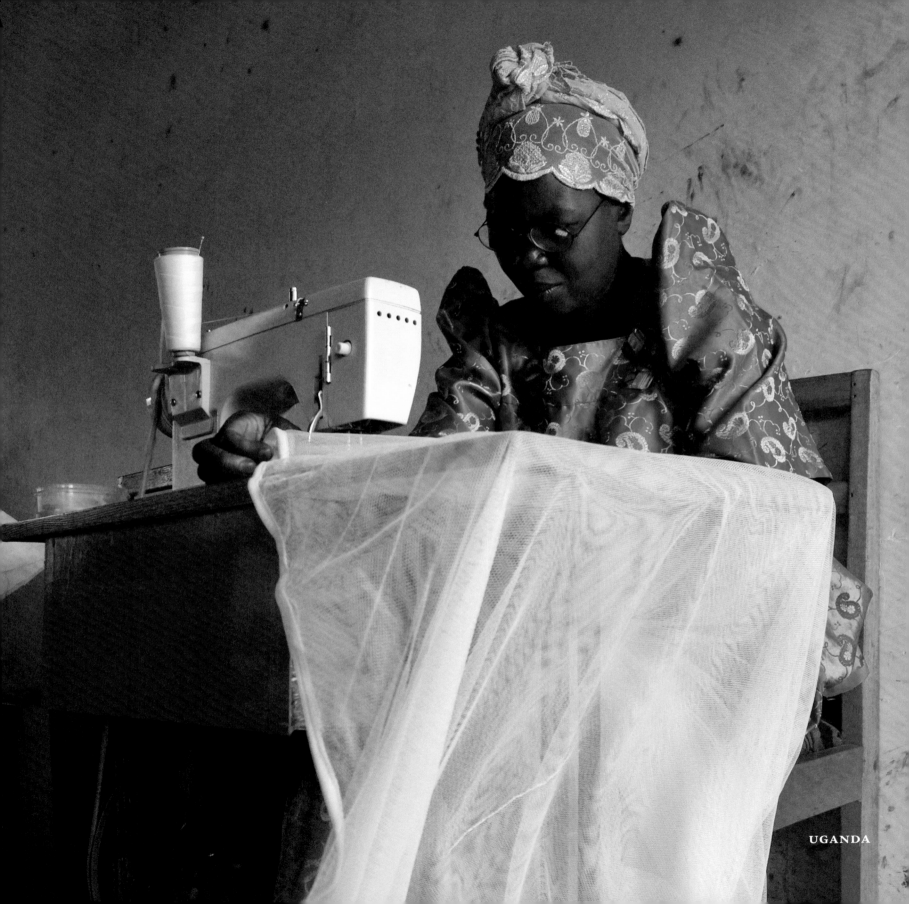

UGANDA

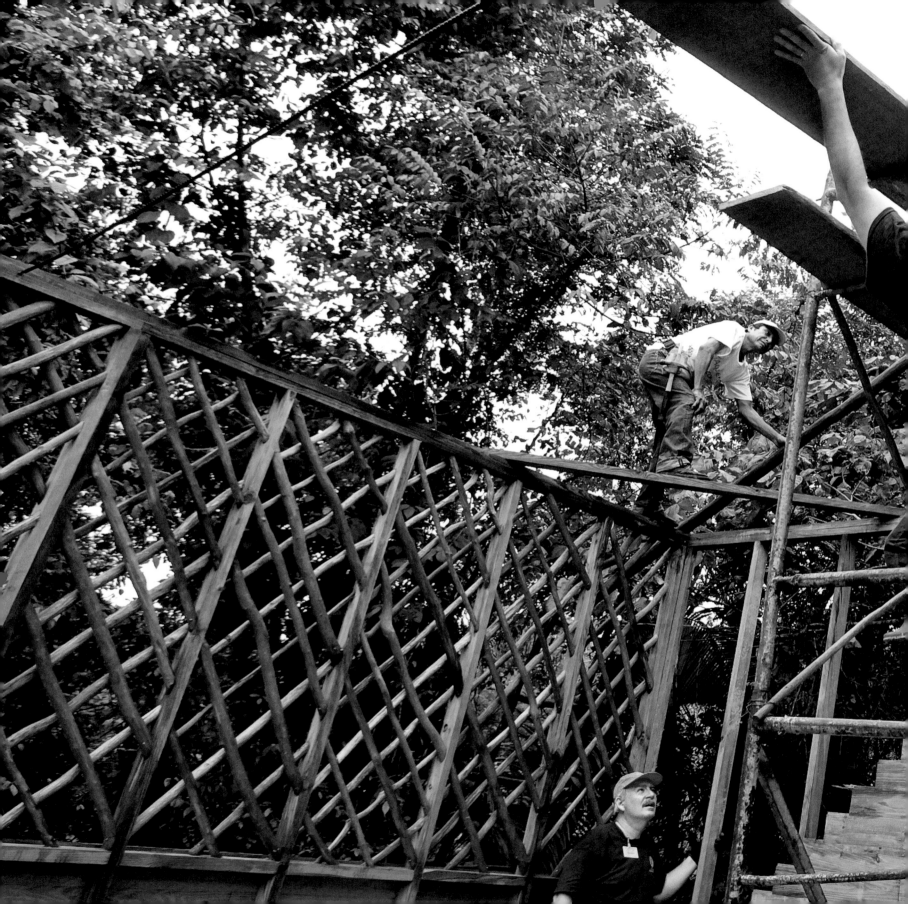

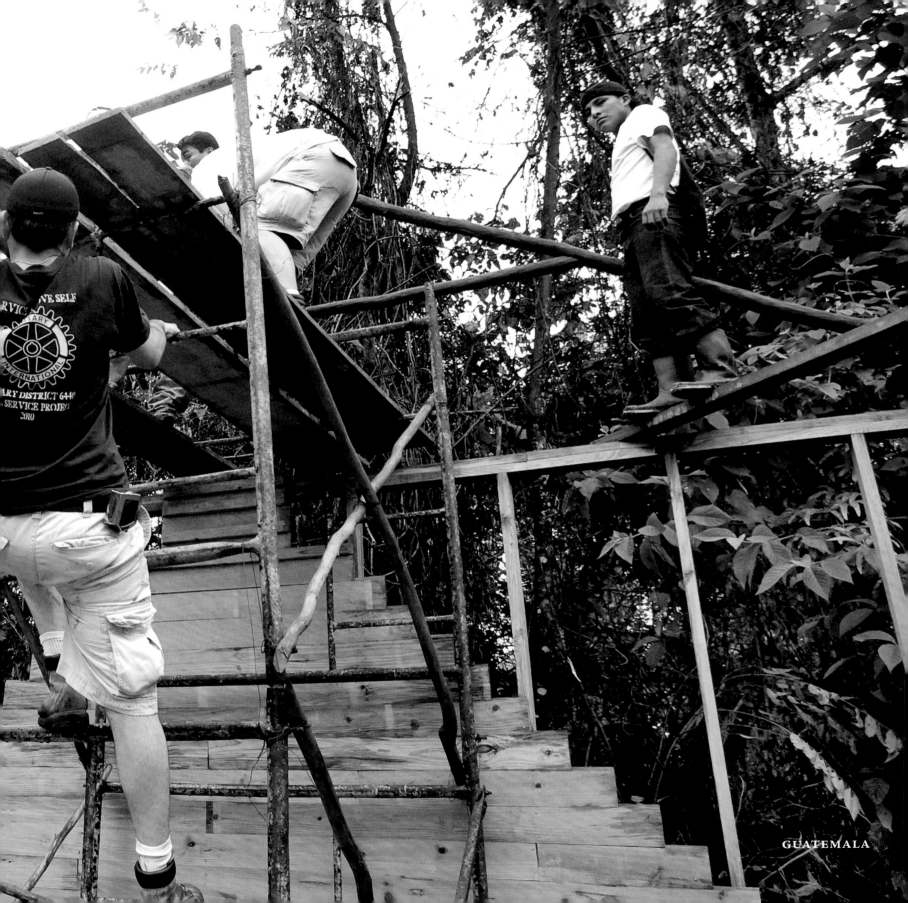

GUATEMALA

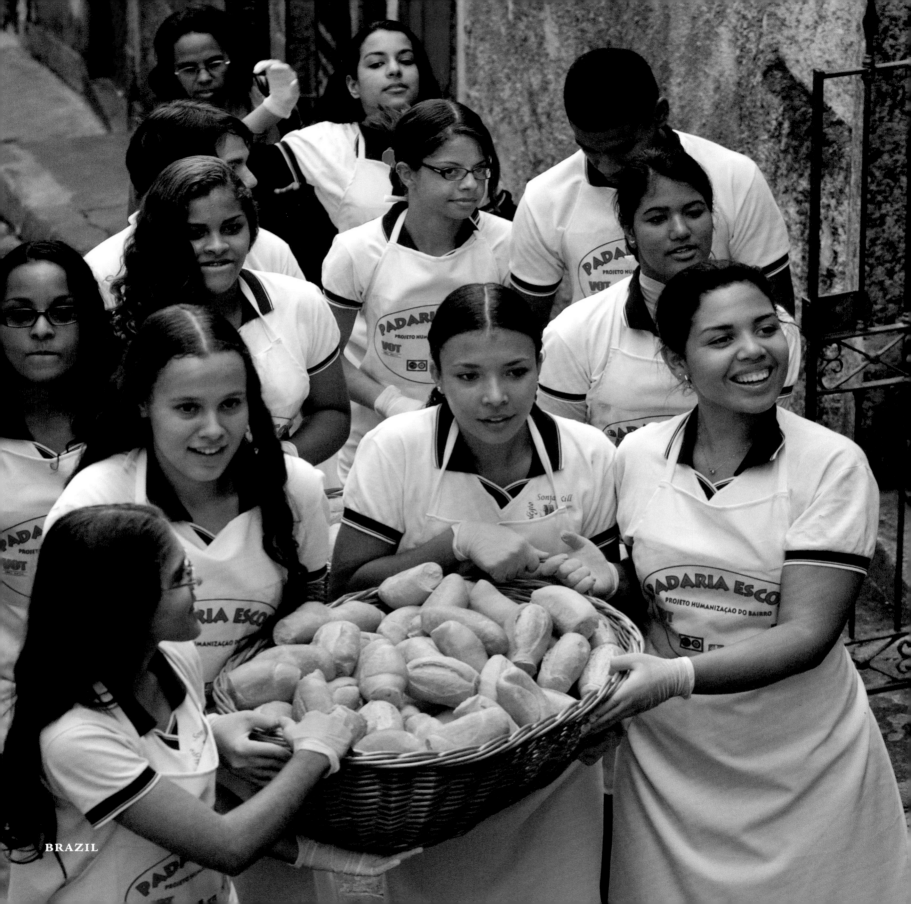

BRAZIL

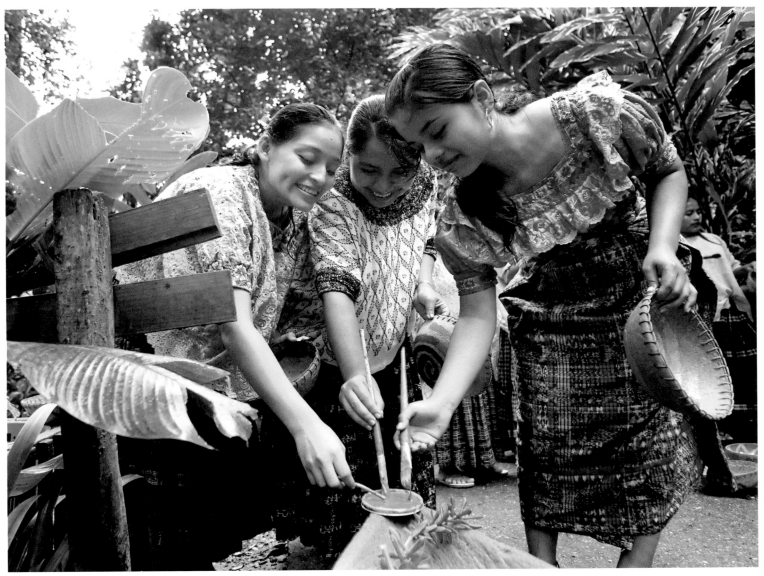

GUATEMALA

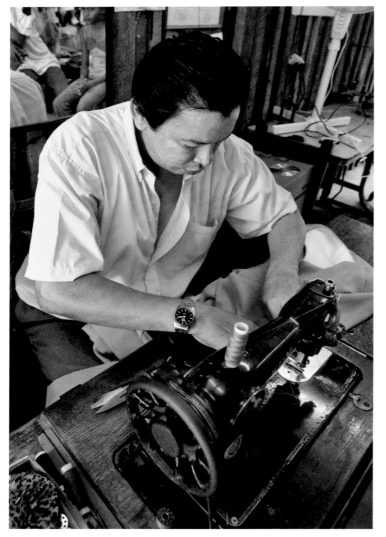

HONDURAS

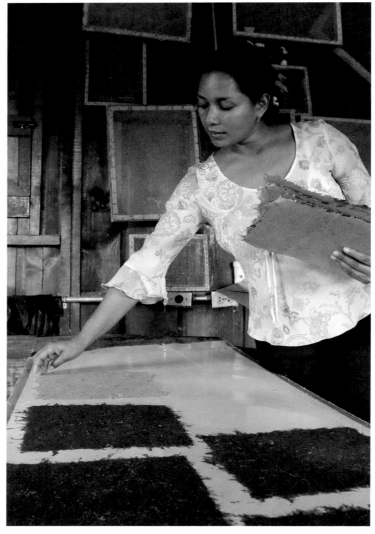

HONDURAS

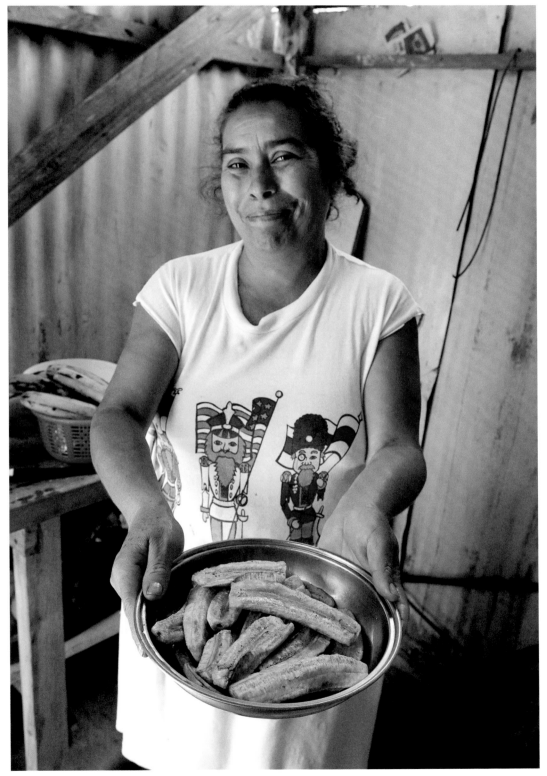

HONDURAS

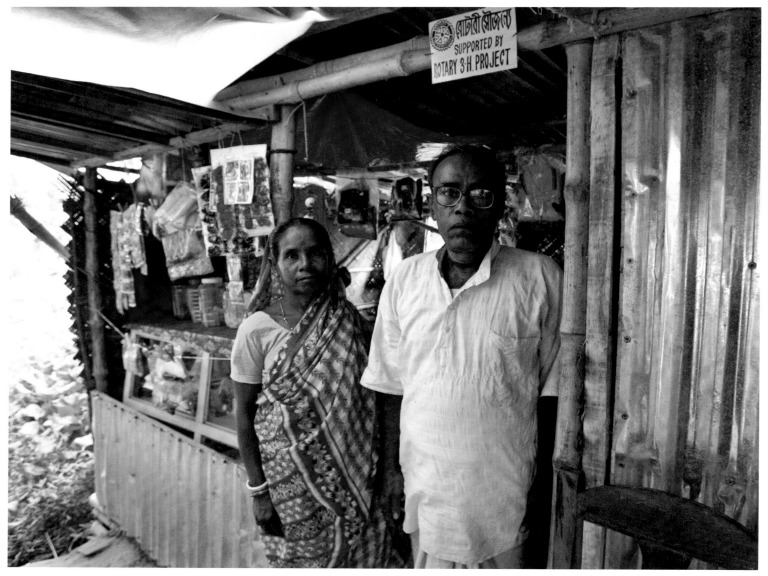

INDIA

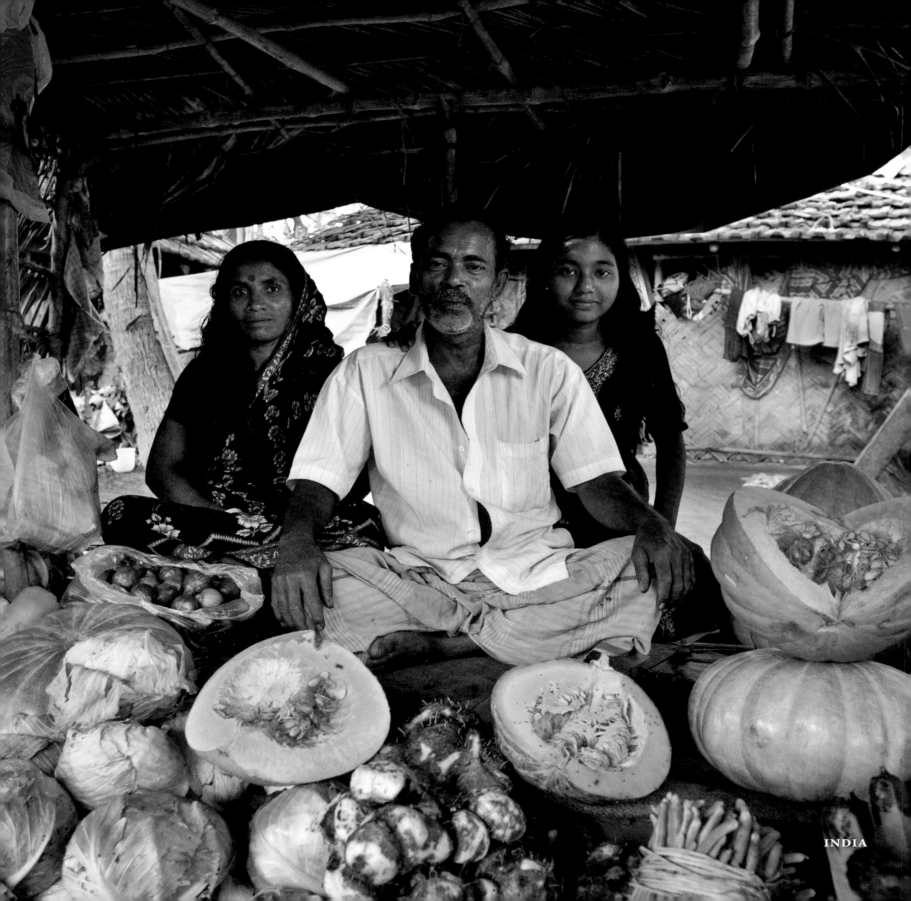

INDIA

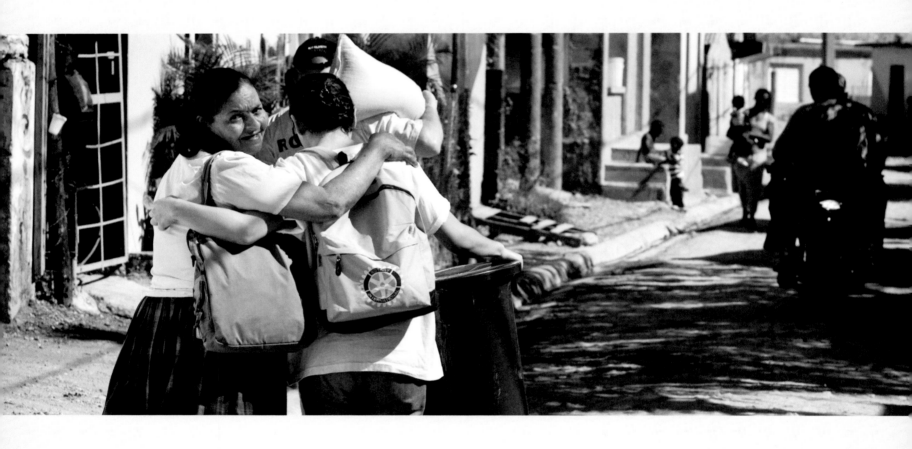

Enjoying fellowship through service

El servicio fomenta el compañerismo

Camaraderie dans le service

奉仕を通じて親睦を深める

봉사를 통해 우정을 나누다

Desfrutando do companheirismo através do servir

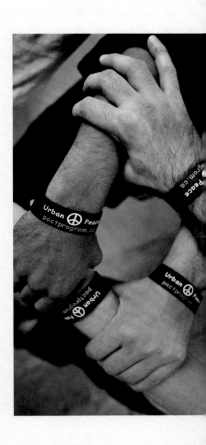

ARGENTINA

ROMANIA

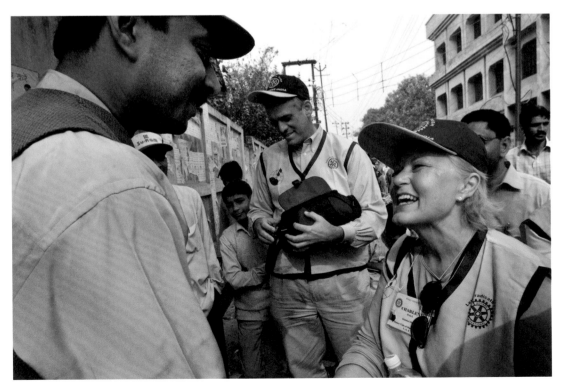

INDIA

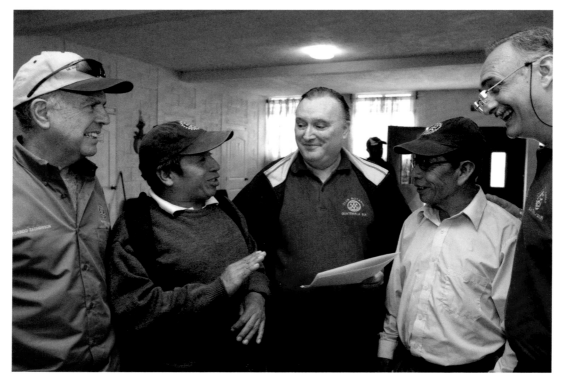

GUATEMALA

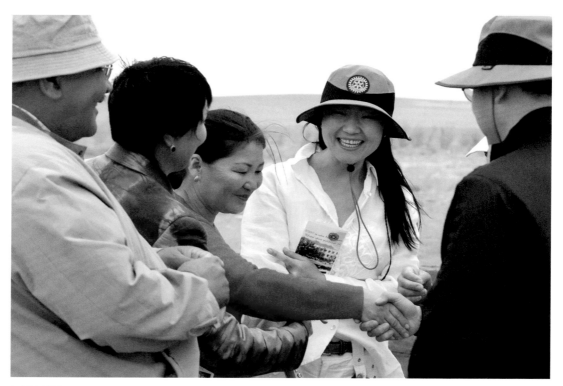

MONGOLIA

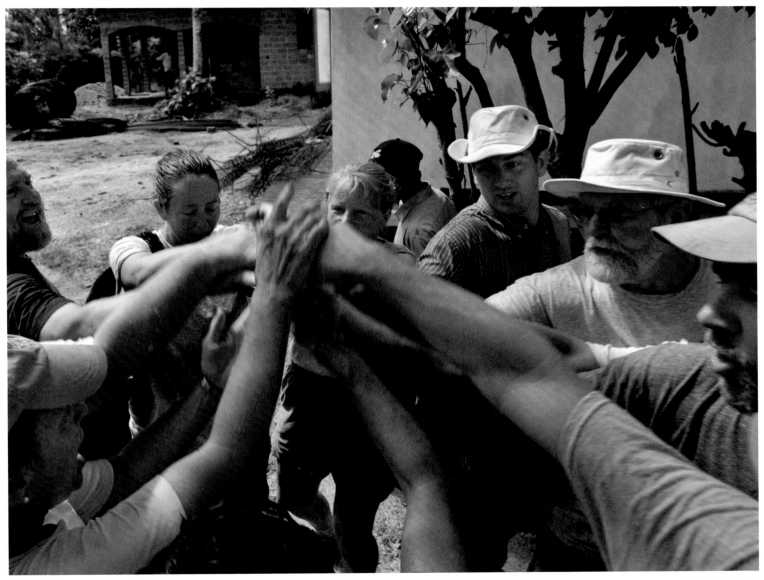

SRI LANKA

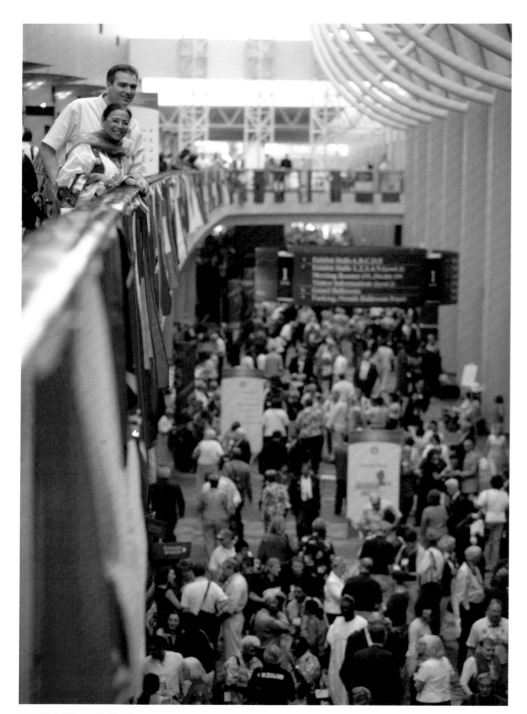

UNITED STATES

CANADA

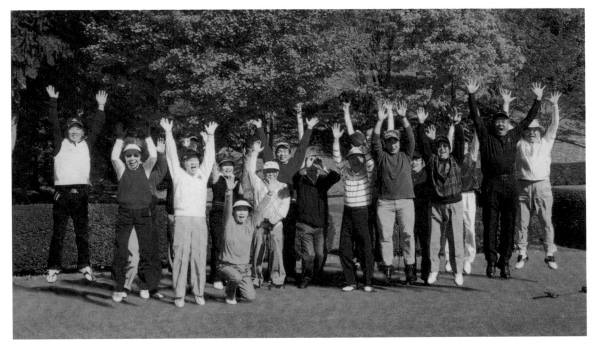

JAPAN

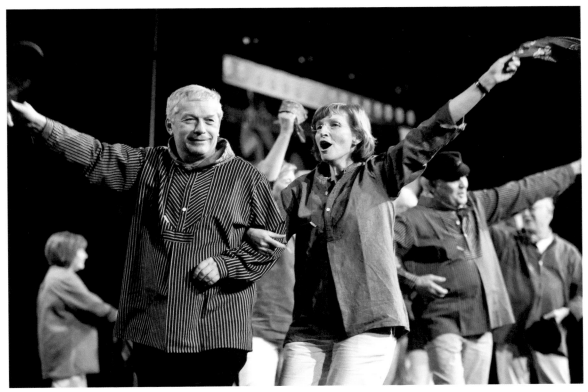

UNITED STATES

CAPTIONS

Eradicating polio globally

PAGES 2-3 • ETHIOPIA 2002 • NIGER 2006 • INDONESIA 2007 • Rotary's PolioPlus program was developed to save the world's children from the crippling effects of the poliovirus.

4 • INDIA 2008 • (left) The precious polio vaccine is preserved through a cold chain process; (right) Rotarians develop strategies for eradicating polio in more remote areas.

5 • INDIA 2008 • Rotarian volunteers go door-to-door immunizing children in remote areas.

6-7 • EGYPT 2004 • INDIA 2010 • NEPAL 2008 • Millions of children receive the polio vaccine on National Immunization Days supported by funding from Rotary International.

8-9 • ETHIOPIA 2002 • INDIA 2006 • Mothers wait patiently for their children to be immunized at National Immunization Days.

10-11 • ETHIOPIA 2002 • Girls display their painted fingers to show they have received the polio vaccine.

12 • ETHIOPIA 2002 • On National Immunization Days, volunteers with bullhorns call out for parents to bring their children to be immunized. **• CHAD 2004 •** The Kick Polio Out of Africa campaign raised awareness across the continent of the importance of immunization.

13 • INDIA 2006 • Children suffering from polio receive reconstructive surgery and rehabilitation at a Rotary-supported hospital.

14 • NIGERIA 2002 • Chalk marks on the doorway indicate that children living in the home have received the polio vaccine.

15 • UNITED STATES 2005 • Rotarians attending Rotary's centennial year convention run a race to end polio.

Meeting basic needs of food, health care, and education

PAGE 18 • UGANDA 2009 • Three orphaned sisters receive financial help and a caregiver from Rotary clubs.

19 • UGANDA 2009 • Students at the Good Samaritan School wear school uniforms sewn by local Rotarians.

20 • UGANDA 2009 • Doctors provide checkups as part of a Rotary project against malaria, poverty, hunger, and illiteracy.

21 • NIGER 2006 • With support from Rotary, the Saga Feeding Center offers nourishment during droughts and other emergencies.

22 • GUATEMALA 2010 • Rotary Foundation grants help to educate and feed the girls at the Fundaniñas orphanage.

23 • DOMINICAN REPUBLIC 2009 • Rotarians provide nutritious daily breakfasts for children in two schools.

24-26 • ARGENTINA 2009 • A Rotary project supports hearing testing and treatment for infants at a local hospital.

27 • HONDURAS 2006 • A family awaits medical attention at a clinic in Nueva Esperanza, a community built by Rotary after Hurricane Mitch. **• GUATEMALA 2010 •** A tiny hand receives critical care at a Rotary-supported pediatric burn clinic.

28-29 • SOUTH AFRICA 2006 • A Rotary-funded preschool provides education and meals for children from families affected by AIDS.

30 • ROMANIA 2006 • Children at an orphanage enjoy milk donated through a Rotary agriculture project.

31 • ROMANIA 2006 • Patients at this children's hospital receive meat and dairy products from local farmers supported by a Rotary Foundation grant.

32-33 • BRAZIL 2007 • Literacy and feeding programs at these schools are supported by Rotary Foundation grants.

34 • TURKEY 2006 • A blind Rotarian spearheaded a club project to record audiobooks for the Beyazit Library.

35 • TURKEY 2006 • Born without arms, Emine Yüzay learned to read and write in a Rotary literacy program and now teaches others.

36-37 • AFGHANISTAN 2004 • A Rotary-sponsored school gives girls their first opportunity for education.

37 • BANGLADESH 2000 • Children learn to read through concentrated language encounter, a revolutionary method introduced by Rotarians to many parts of the world.

38 • INDIA 2006 • Basic education is a key component of many larger integrated Rotary projects.

39 • INDIA 2006 • A water-harvesting project increases agricultural output and variety to help feed the village residents.

40 • FRANCE 2008 • Alzheimer's patients are engaged in activities at a Rotary-supported day center that gives caregivers some time off.

41-43 • UNITED STATES 2007 • Rotarian volunteers staff and support a mobile food pantry that serves low-income neighborhoods.

Providing clean water, sanitation facilities, and hygiene education

PAGES 46-49 • INDIA 2006 • With support from The Rotary Foundation, Rotarians and village volunteers built a retaining wall to keep wells from going dry and the water supply sufficient.

50 • DOMINICAN REPUBLIC 2009 • A Rotarian installs a bio-sand filter that ensures clean drinking water for the family.

51 • ARGENTINA 2010 • A Rotary-sponsored clean-hands project instills good sanitation habits at an early age.

52-53 • PERU 2010 • A hundred bio-sand filters, purchased with a Rotary Foundation grant and installed by Rotarians, will bring clean water to 1,500 people.

54 • GUATEMALA 2010 • Rotarians hiked through the rain forest carrying water filters, which they delivered and assembled in remote river communities.

55 • PERU 2008 • Rotary Foundation grants funded the construction of outdoor sinks to provide a source of clean water for the community.

56 • **UGANDA 2009** • This borehole is part of a larger Rotary Foundation project designed to fight disease, improve agriculture, and reduce poverty.

57 • **BANGLADESH 2000** • A child enjoys a drink of clean water from a Rotary-sponsored well.

58-59 • **NIGER 2006** • Wells supported by Rotary Foundation grants provide a welcome source of clean water in many parts of the world.

Helping young people develop valuable skills

PAGES 62-63 • **UNITED STATES 2009** • **SWEDEN 2006** • Through the Rotary Youth Leadership Awards (RYLA) program, young people develop confidence and leadership skills.

64 • **CANADA 2009** • The Rotary-sponsored PACT program helps former youth offenders gain valuable life skills.

65 • **FRANCE 2009** • (*top*) Young students learn how to make pastry in a project run by members of Interact, a Rotary-sponsored youth service program; (*bottom*) A journalism award sponsored by the French Rotary magazine gives young broadcast journalists the opportunity to produce films.

66 • **UNITED STATES 2007** • Carpentry students learn how to build a single-family home in a Rotary program, which then sells the homes and provides scholarships. • **BRAZIL 2007** • A Rotary project trains at-risk youth to become electricians.

67 • **UNITED STATES 2009** • Members of Rotaract, Rotary's service club for young adults, help children with disabilities by building an accessible playground.

Responding and rebuilding after disaster strikes

PAGE 70 • **THAILAND 2005** • After the tsunami, Rotary Foundation grants helped the fishing industry to rebound.

71 • **THAILAND 2005** • Rotarian volunteers work to rebuild in tsunami-ravaged areas. • **PAKISTAN 2010** • Rotarians supported temporary shelters for those left homeless after devastating floods.

72 • **SRI LANKA 2005** • Rotarian volunteers work to rebuild homes destroyed by the tsunami.

73-75 • **SRI LANKA 2005 AND 2009** • Rotary's Schools Re-awaken project built 25 schools to replace those lost in the tsunami.

76-77 • **UNITED STATES 2005** • In the wake of Hurricane Katrina, Rotarians provided temporary housing (*left*) and gathered supplies for people in need (*right*).

78 • **UNITED STATES 2008** • Rotary clubs assisted victims of wildfires in California (*top*) and floods in Iowa (*bottom*).

79 • **PERU 2010** • Young adult members of Rotaract clear the rubble after a powerful earthquake rocked the country.

80-81 • **HAITI 2010** • Rotary-supported temporary housing sheltered hundreds of people left homeless by a catastrophic earthquake.

Preserving Planet Earth

PAGES 84-87 • **MONGOLIA 2008** • Rotary's Keep Mongolia Green project involves planting a community garden and building a windbreak forest in the Gobi.

88 • **JAPAN 2009** • Schoolchildren learn about the environment by participating in a Rotary project to clean a river.

89 • **UNITED STATES 2005** • Rotary clubs provide solar ovens to developing countries as an alternative to wood-burning stoves that can cause air pollution and deforestation.

Supporting economic development

PAGE 92 • **SOUTH AFRICA 2006** • Women learn how to handstitch shoes in this Rotary project that uses its profits to support a center for AIDS orphans.

93 • **UGANDA 2009** • Using machines provided by Rotary clubs, women learn sewing skills and make protective mosquito nets.

94-95 • **GUATEMALA 2010** • Rotarians work with Maya community members to build a library as part of a larger community development project.

96 • **BRAZIL 2007** • Students learn breadmaking skills and sell their products at a baking school funded by The Rotary Foundation.

97 • **GUATEMALA 2010** • Members of the Women's Handicraft Cooperative in a Rotary-supported community paint handcrafted bowls to sell as souvenirs.

98-99 • **HONDURAS 2006** • Rotary-funded microcredit loans help residents open small businesses in tailoring, papermaking, and food sales.

100-101 • **INDIA 2006** • Families set up small grocery stores with start-up funds from a Rotary-supported microcredit loan.

Enjoying fellowship through service

PAGE 104 • **ARGENTINA 2010** • Project planners display the promotional materials for their clean-hands project.

105 • **ROMANIA 2006** • Rotarian volunteers talk with a local farmer who received livestock through a Rotary project. • **INDIA 2006** • Rotarians from polio-free countries join with local Rotarians to participate in National Immunization Days.

106 • **GUATEMALA 2010** • Rotarians meet with local residents to discuss plans for a farming project to benefit a Rotary-supported orphanage. • **MONGOLIA 2007** • Rotarians and villagers share the work on an environmental project.

107 • **SRI LANKA 2007** • Rotarians celebrate after building a home for displaced people.

108 • **UNITED STATES 2007** • A Rotary convention brings members together from every part of the world to celebrate Service Above Self. • **CANADA 2009** • Club meetings offer an opportunity to plan projects and build friendships.

109 • **JAPAN 2009** • A club golf outing is one type of social activity that fosters camaraderie among members. • **UNITED STATES 2010** • At the International Assembly, Rotarians wear traditional dress of their homelands to demonstrate the internationality of Rotary.

PIES DE FOTOS

Erradicación mundial de la polio

PÁGINAS 2-3 • ETIOPÍA 2002 • NÍGER 2006 • INDONESIA 2007 • El programa PolioPlus de Rotary se creó para rescatar a la niñez del mundo de las garras del poliovirus.

4 • INDIA 2008 • *(izq.)* Proceso de la cadena fría para la conservación de la preciada vacuna contra la polio; *(der.)* Los rotarios crean estrategias de erradicación para las áreas más remotas.

5 • INDIA 2008 • Vacunación de puerta en puerta en áreas remotas.

6-7 • EGIPTO 2004 • INDIA 2010 • NEPAL 2008 • Millones de niños reciben la vacuna contra la polio gracias a La Fundación Rotaria.

8-9 • ETIOPÍA 2002 • INDIA 2006 • Madres esperan pacientemente que sus niños sea vacunados durante las Jornadas Nacionales de Vacunación.

10-11 • ETIOPÍA 2002 • Dedos pintados, vacuna recibida.

12 • ETIOPÍA 2002 • Un llamado a los padres para que acudan a vacunar a sus hijos. **• CHAD 2004 •** La campaña Kick Polio Out of Africa (Tiro Libre a la Polio) crea conciencia en el continente africano sobre la vacunación.

13 • INDIA 2006 • El aporte económico de Rotary hace posible la rehabilitación y cirugía reconstructiva para víctimas de la polio.

14 • NÍGERIA 2002 • Marcas de tiza en el umbral de las casas de niños vacunados contra la polio.

15 • ESTADOS UNIDOS 2005 • Rotarios en la carrera para dar fin a la polio durante la Convención del centenario de Rotary.

Alimentación, atención a la salud y educación

PÁGINA 18 • UGANDA 2009 • Tres jovencitas huérfanas reciben cuidado y ayuda económica gracias a los clubes rotarios.

19 • UGANDA 2009 • Niños de Good Samaritan School lucen uniformes confeccionados por rotarios.

20 • UGANDA 2009 • Los proyectos de Rotary combaten la malaria, la pobreza, el hambre y el analfabetismo.

21 • NÍGER 2006 • El Saga Feeding Center ofrece alimentación en tiempos de sequía.

22 • GUATEMALA 2010 • Las subvenciones de La Fundación Rotaria ayudan a educar y alimentar a las niñas huérfanas de Fundaniñas.

23 • REPÚBLICA DOMINICANA 2009 • Gracias a Rotary, los estudiantes disfrutan de desayunos nutritivos.

24-26 • ARGENTINA 2009 • Pruebas auditivas y tratamiento en un hospital infantil construido con el aporte económico de Rotary.

27 • HONDURAS 2006 • Una familia espera recibir atención médica en la comunidad Nueva Esperanza reconstruida por Rotary. **• GUATEMALA 2010 •** La manito agradecida por el tratamiento crítico de quemaduras que recibe en la clínica pediátrica.

28-29 • SUDÁFRICA 2006 • Un centro preescolar financiado por Rotary ofrece educación y alimentación a niños de familias afectadas por el SIDA.

30 • RUMANIA 2006 • Gracias a un proyecto agrícola, los niños huérfanos reciben leche.

31 • RUMANIA 2006 • Este hospital infantil recibe productos lácteos y carne de productores agrícolas que se benefician de una subvención de La Fundación Rotaria.

32-33 • BRASIL 2007 • Los aportes de La Fundación Rotaria hacen posible los programas de alfabetización y nutrición.

34 • TURQUÍA 2006 • Un rotario invidente creó un proyecto de audiolibros en la biblioteca de Beyazit.

35 • TURQUÍA 2006 • Emine Yüzay pudo aprender a leer y escribir en un programa de alfabetización de Rotary a pesar de haber nacido sin brazos, y ahora enseña a otros.

36-37 • AFGHANISTÁN 2004 • Con el respaldo de Rotary, estas niñas tienen por primera vez la oportunidad de estudiar.

37 • BANGLADESH 2000 • Los niños aprenden a leer con el método CLE en muchas áreas del mundo.

38 • INDIA 2006 • La educación básica es parte integral de muchos proyectos de Rotary.

39 • INDIA 2006 • Un proyecto de captación de agua para mejorar la producción agrícola y la alimentación de los habitantes de esta comunidad.

40 • FRANCIA 2008 • Actividades físicas para pacientes que sufren de Alzheimer.

41-43 • ESTADOS UNIDOS 2007 • Voluntarios rotarios trabajan y financian este almacén de comida rodante que beneficia a comunidades pobres.

Agua potable, instalaciones sanitarias e higiene

PÁGINAS 46-49 • INDIA 2006 • Con el apoyo de La Fundación Rotaria, voluntarios rotarios y de la comunidad construyen un muro de retención para que de los pozos siga fluyendo agua potable.

50 • REPÚBLICA DOMINICANA 2009 • Un rotario instala filtros de bioarena que suplen de agua potable a las familias.

51 • ARGENTINA 2010 • Los buenos hábitos de sanidad se inculcan desde la más temprana edad.

52-53 • PERÚ 2010 • Cien filtros de bioarena adquiridos con una subvención de La Fundación Rotaria e instalados por rotarios, traerán agua potable a 1.500 personas.

54 • GUATEMALA 2010 • Los rotarios portaron filtros de agua por la selva tropical para instalarlos en comunidades remotas.

55 • PERÚ 2008 • Gracias a La Fundación Rotaria se pudieron construir lavaderos para proporcionar agua potable a la comunidad.

56 • UGANDA 2009 • Este pozo es parte de un proyecto de envergadura cuyo objetivo es controlar enfermedades, mejorar la agricultura y reducir la pobreza.

LÉGENDES

Éradication de la polio dans le monde

PAGES 2-3 • ETIOPIE 2002 • NIGER 2006 • INDONESIE 2007 • Le programme PolioPlus du Rotary a été lancé pour sauver tous les enfants du monde des effets dévastateurs de la polio.

4 • INDE 2008 • (*À g.*) Conservation du précieux vaccin contre la polio ; (*à d.*) Réflexion sur des stratégies d'éradication de la polio.

5 • INDE 2008 • Porte-à-porte pour la vaccination des enfants.

6-7 • EGYPTE 2004 • INDE 2010 • NEPAL 2008 • Des millions d'enfants sont vaccinés contre la polio lors des Journées nationales de vaccination financées par le Rotary International.

8-9 • ETIOPIE 2002 • INDE 2006 • L'attente avant d'être vaccinés.

10-11 • ETIOPIE 2002 • On est fiers de montrer son petit doigt marqué à l'encre, preuve que l'on vient d'être vaccinés.

12 • ETIOPIE 2002 • Appel aux parents à faire vacciner leurs enfants. **• TCHAD 2004 •** Matériel utilisé lors de la campagne de sensibilisation *Kick Polio Out of Africa* (Bouter la polio hors d'Afrique).

13 • INDE 2006 • Chirurgie réparatrice et rééducation des enfants atteints de la polio.

14 • NIGERIA 2002 • On marque les maisons des enfants vaccinés à la craie.

15 • ÉTATS-UNIS 2005 • Course en soutien des efforts d'éradication de la polio.

Besoins alimentaires, sanitaires et éducatifs

PAGE 18 • OUGANDA 2009 • Trois sœurs orphelines bénéficient d'une aide financière et d'une auxiliaire de vie.

19 • OUGANDA 2009 • Les élèves de l'école *Good Samaritan* portent fièrement les uniformes confectionnés par les Rotariens locaux.

20 • OUGANDA 2009 • Examen de santé dans le cadre d'une action du Rotary.

21 • NIGER 2006 • Le Centre alimentaire *Saga* apporte une aide alimentaire en période de sécheresse ou en cas d'urgence.

22 • GUATEMALA 2010 • L'orphelinat Fundaniñas soutenu par la Fondation Rotary.

23 • REPUBLIQUE DOMINICAINE 2009 • Distribution de petits-déjeuners consistants aux élèves.

24-26 • ARGENTINE 2009 • Test de l'ouïe à l'hôpital local.

27 • HONDURAS 2006 • Avant l'arrivée du médecin dans un dispensaire de Nueva Esperanza, un village reconstruit par le Rotary. **• GUATEMALA 2010 •** Des soins critiques pour soigner une petite main brulée.

28-29 • AFRIQUE DU SUD 2006 • École maternelle financée par le Rotary pour les enfants de familles touchées par le SIDA.

30 • ROUMANIE 2006 • Les enfants de cet orphelinat apprécient le lait fourni par les fermiers locaux.

31 • ROUMANIE 2006 • Médecin au chevet d'un jeune patient.

32-33 • BRESIL 2007 • Des subventions de la Fondation Rotary financent les programmes alimentaires et d'alphabétisation en place dans ces écoles.

34 • TURQUIE 2006 • Un Rotarien non-voyant à l'origine d'une action fournissant des livres audio à la bibliothèque Beyazit.

35 • TURQUIE 2006 • Née sans bras, Emine Yüzay qui a appris à lire et à écrire grâce à un programme d'alphabétisation du Rotary, enseigne aujourd'hui.

36-37 • AFGHANISTAN 2004 • Découverte de l'école pour ces jeunes filles dans une école parrainée par le Rotary.

37 • BANGLADESH 2000 • Utilisation de la méthode C.L.E. à l'école primaire.

38 • INDE 2006 • L'éducation, un élément clé de multiples actions d'envergure du Rotary.

39 • INDE 2006 • Un captage de l'eau a permis d'accroître la quantité et la variété des récoltes.

40 • FRANCE 2008 • Activités physiques pour patients atteints de la maladie d'Alzheimer.

41-43 • ÉTATS-UNIS 2007 • Épicerie mobile desservant les quartiers défavorisés.

Eau, assainissement et éducation à l'hygiène

PAGES 46-49 • INDE 2006 • Avec le soutien de la Fondation Rotary, les Rotariens et les villageois ont construit un barrage pour éviter l'assèchement des puits.

50 • REPUBLIQUE DOMINICAINE 2009 • Après l'installation d'un filtre à sable, une famille dispose d'eau potable.

51 • ARGENTINE 2010 • De bonnes habitudes dès le plus jeune âge.

52-53 • PÉROU 2010 • Cent filtres à sable achetés grâce à une subvention de la Fondation Rotary et installés par les Rotariens donnent accès à l'eau potable à 1 500 villageois.

54 • GUATEMALA 2010 • Transport et installation de filtres dans des villages isolés.

55 • PÉROU 2008 • Une eau limpide coule maintenant des fontaines du village.

56 • OUGANDA 2009 • L'eau, élément essentiel d'une action visant à lutter contre les maladies, améliorer l'agriculture et réduire la pauvreté.

57 • BANGLADESH 2000 • À la fontaine du village.

58-59 • NIGER 2006 • Partout dans le monde, des subventions de la Fondation financent des actions visant à assurer l'accès à l'eau potable.

Développement professionnel des jeunes

PAGES 62-63 • ÉTATS-UNIS 2009 • SUÈDE 2006 • Les séminaires RYLA (Rotary Youth Leadership Awards) proposent une formation au leadership et au développement personnel des jeunes.

写真キャプション

世界的ポリオ撲滅活動

2-3ページ ● 2002年 エチオピア ● 2006年 ニジェール ● 2007年 インドネシア ● ロータリーのポリオ・プラスは、深刻な影響をもたらすポリオウィルスから世界中の子供たちを救うために開始されました。

4 ● 2008年 インド ● （左）コールドチェーンプロセスにより保存される貴重なポリオワクチン。（右）遠隔地におけるポリオ撲滅の戦略に携わるロータリアン。

5 ● 2008年 インド ● 遠隔地で一軒ずつ周り、子供たちに予防接種するロータリアン。

6-7 ● 2004年 エジプト ● 2010年 インド ● 2008年 ネパール ● 国際ロータリーの資金援助を得て、予防接種デーにおいてポリオワクチンを受ける何百万もの子供たち。

8-9 ● 2002年 エチオピア ● 2006年 インド ● 予防接種デーで、子供たちの予防接種を辛抱強く待つ母親たち。

10-11 ● 2002年 エチオピア ● ポリオワクチン接種を受けたことを示す指を見せる女の子たち。

12 ● 2002年 エチオピア ● 予防接種デーにて、子供たちに接種を受けさせるように、親達に声をかけるボランティア。**● 2004年 チャド ●** 予防接種の重要性に対する意識をアフリカ大陸全土で高めた「アフリカ・キックアウト・ポリオ」キャンペーン。

13 ● 2006年 インド ● ロータリーの支援を受けた病院で、再建手術やリハビリを受けるポリオと闘う子供たち。

14 ● 2002年 ナイジェリア ● 子供たちがポリオワクチンを受けたことを表すドアに書かれたマーク。

15 ● 2005年 米国 ● ロータリー100周年記念大会に参加し、ポリオ撲滅のために走るロータリアン。

食糧・保健・教育といった基本的ニーズに応える

18ページ ● 2009年 ウガンダ ● ロータリークラブから補助金と世話人の提供を受ける3人の孤児姉妹。

19 ● 2009年 ウガンダ ● 地元ロータリアンが縫った制服を着るGood Samaritan Schoolの学生。

20 ● 2009年 ウガンダ ● マラリア、貧困、飢餓、識字などのロータリープロジェクトの一環で検診を行う医者。

21 ● 2006年 ニジェール ● ロータリーの支援の下、干ばつやその他緊急事態の間、食料を提供するサガ供給センター。

22 ● 2010年 グアテマラ ● Fundaniñas孤児院で、ロータリー財団の補助金により教育や食料提供を受ける女の子たち。

23 ● 2009年 ドミニカ共和国 ● 2つの学校で、毎朝栄養価の高い朝食を提供するロータリアン。

24-26 ● 2009年 アルゼンチン ● ロータリーのプロジェクト支援の下、乳幼児の聴力検査や治療が行われている病院。

27 ● 2006年 ホンジュラス ● ハリケーン・ミッチの後、ロータリーによって設立されたヌエバ・エスペランザ地区のクリニックで治療を待つ家族。**● 2010年 グアテマラ ●** ロータリーが支援する小児熱傷クリニックにて救命措置を受ける小さな手。

28-29 ● 2006年 南アフリカ ● ロータリーの補助金が支援する幼稚園で、教育と食事を提供される、エイズ孤児。

30 ● 2006年 ルーマニア ● 孤児院で、ロータリーの農業プロジェクトを通じて寄付された牛乳を飲む子供たち。

31 ● 2006年 ルーマニア ● ロータリー財団による補助金の支援を受けた地元の農家から、肉や乳製品をもらう入院中の子供たち。

32-33 ● 2007年 ブラジル ● ロータリー財団の補助金の支援を受けた識字や食料配給プログラム。

34 ● 2006年 トルコ ● Beyazit図書館で、音声付図書の録音プログラムを先導する、盲目のロータリアン。

35 ● 2006年 トルコ ● 両腕の無い状態で生まれたEmine Yüzayさんは、ロータリーの識字プログラムで読み書きを覚え、今はほかの女性たちに教えています。

36-37 ● 2004年 アフガニスタン ● ロータリーが支援する学校で、生まれて初めて教育機会が与えられた女の子たち。

37 ● 2000年 バングラデシュ ● 世界中多くの地域で、ロータリアンが考案した集中言語能力助長プログラムの教育法で読書を習う子供たち。

38 ● 2006年 インド ● ロータリーが実施する包括的な大型プロジェクトの鍵は、基本的教育です。

39 ● 2006年 インド ● 貯水プロジェクトにより、農産物の収穫量や種類が増えました。

40 ● 2008年 フランス ● 看護者に休息の時間を与えるため、ロータリーが支援するデイケアセンターで、アルツハイマー患者のケアが行われています。

41-43 ● 2007年 米国 ● 移動食料貯蔵トラックで低所得者層居住地域を周るロータリアンのボランティアスタッフ。

きれいな水・公衆衛生施設や衛生教育をかなえる

46-49ページ ● 2006年 インド ● ロータリー財団の支援の下、井戸の枯渇を防ぎ、水の十分な供給を確保するための貯水所をを作るロータリアンと村人。

50 ● 2009年 ドミニカ共和国 ● きれいな飲み水を確保するためのバイオサンド・フィルターを設置するロータリアン。

51 ● 2010年 アルゼンチン ● ロータリーの支援による「きれいな手」プロジェクトで、衛生の大切さを学ぶ子供たち。

52-53 ● 2010年 ペルー ● ロータリー財団補助金の支援の下、ロータリアンが設置した100個のバイオサンド・フィルター。これらのフィルターが、1,500人の住民にきれいな水をもたらします。

54 ● 2010年 グアテマラ ● 遠隔地に、水のろ過フィルターを届けるため、熱帯雨林の中を長時間歩くロータリアン。

55 ● 2008年 ペルー ● 地域の人々にきれいな水を提供するため、屋外に設置された蛇口から水を飲む少女。

56 ● 2009年 ウガンダ ● ロータリー財団プロジェクトの一部で、疾病予防、農業開発、貧困減少のために設置されたされた掘削孔。

57 ● 2000年 バングラデシュ ● ロータリーの支援によって設置された井戸からきれいな水を飲む子供。

58-59 ● 2006年 ニジェール ● ロータリー財団補助金によって設置された数々の井戸は、世界各地にきれな水をもたらしています。

青少年に価値ある教育を

62-63ページ ● 2009年 米国 ● 2006年 スウェーデン ● 多種多様な分野で、青少年の指導力スキルを向上させる、ロータリー青少年指導者育成プログラム。

64 ● 2009年 カナダ ● ロータリー支援で、価値ある人生に必要なスキルを得るため、青少年の元犯罪者に救いの手を差し伸べるPACTプログラム。

65 ● 2009年 フランス ● （上）ロータリーの青少年向けプログラムであるインターアクトのメンバーによるプログラムで、菓子作りを学ぶ学生。（下）フランスのロータリー雑誌の援助で、映画製作の機会を得、ジャーナリズムの賞を受ける青少年報道ジャーナリスト。

66 ● 2007年 米国 ● ロータリーのプログラムで、一戸建て住宅の建て方を学ぶ大工業専攻の生徒たち。これらの家は実際に競売にかけられるだけでなく、その収益で奨学金も提供しています。● 2007年 ブラジル ● 非行に走る可能性のある青少年に、電気技師になるための訓練を提供するロータリーのプロジェクト。

67 ● 2009年 米国 ● バリアフリーの遊び場を作り、障害のある子供たちを支援するローターアクター。

災害に対応し、その後の再建を支える

70ページ ● 2005年 タイ ● 津波の後、ロータリー財団の補助金で復興支援された漁業。

71 ● 2005年 タイ ● 津波に見舞われた地域で再建活動に従事するロータリアン。● 2010年 パキスタン ● 破壊的洪水により家を失った人々に、一時的シェルターを提供するロータリアン。

72 ● 2005年 スリランカ ● 津波によって破壊された家を再建するために働くロータリアンボランティア。

73-75 ● 2005年及び2009年 スリランカ ● ロータリーのSchools Re-awakenプロジェクトで再建された25の学校。

76-77 ● 2005年 米国 ● ハリケーン・カトリーナの後、仮の住居を提供したり（左）必要としている人々のため、必要物資を集めるロータリアン（右）。

78 ● 2008年 米国 ● カリフォルニアの山火事（上）と、アイオワの洪水（下）の被災者を支援するロータリークラブ。

79 ● 2010年 ペルー ● 大地震後の瓦礫を除去するローターアクター。

80-81 ● 2010年 ハイチ ● 大地震によって家を失った何百人もの人々に、仮住居を提供しているロータリー。

地球を守るために

84-87ページ ● 2008年 モンゴル ● ロータリーの「モンゴルに緑を」プロジェクト。この活動では、菜園づくりやコビ砂漠付近の防砂林のための植樹が行われています。

88 ● 2009年 日本 ● ロータリーの河川浄化プロジェクトに参加し、環境について学ぶ生徒たち。

89 ● 2005年 米国 ● 空気汚染や森林破壊を招く恐れのある木製オーブンに代わり、ロータリークラブが提供した太陽熱を利用したオーブン。

経済の発展を支援する

92ページ ● 2006年 南アフリカ ● ロータリーのプロジェクトで、靴の手縫いを学ぶ女性たち。同プロジェクトの収益は、エイズ孤児支援センターで活用されています。

93 ● 2009年 ウガンダ ● ロータリーが提供したミシンで、裁縫技術を学び、蚊帳を縫う女性たち。

94-95 ● 2010年 グアテマラ ● 大規模コミュニティ開発プロジェクトとして、図書館を設立するため、マヤの人々と働くロータリアン。

96 ● 2007年 ブラジル ● ロータリー財団補助金の支援を受けた学校で製パン技術を学び、焼き立てのパンを売り歩く生徒たち。

97 ● 2010年 グアテマラ ● 土産物として売るための手作りボウルに色付けをする、ロータリー支援の「女性のための手工芸共同組合」メンバー。

98-99 ● 2006年 ホンジュラス ● ロータリーのマイクロクレジット・ローンの支援を受け、洋服仕立、製紙や食品販売などの零細事業を始めた人々。

100-101 ● 2006年 インド ● ロータリーのマイクロクレジット・ローンにより、小さな食料品店の回転資金を得た家族。

奉仕を通じて親睦を深める

104ページ ● 2010年 アルゼンチン ● 「きれいな手」プロジェクトで作成した資料やキットを見せるボランティアたち。

105 ● 2006年 ルーマニア ● ロータリーのプロジェクトを通じて家畜をもらった地元農家と話すロータリアンボランティア。● 2006年 インド ● 地元ロータリアンと共に予防接種デーに参加するロータリアン。

106 ● 2010年 グアテマラ ● ロータリーが支援する孤児院のための農業プロジェクトについて、地元住民と話し合うロータリアン。● 2007年 モンゴル ● 環境プロジェクトにおいて、地元住民と一緒に活動するロータリアン。

107 ● 2007年 スリランカ ● 災害で自宅を失った人たちのための家の完成を祝うロータリアン。

108 ● 2007年 米国 ● 「超我の奉仕」を祝うために世界中から会員が集うロータリーの国際大会。● 2009年 カナダ ● クラブ例会は、プロジェクトの計画や親睦の機会です。

109 ● 2009年 日本 ● 会員の連帯感を育むためのゴルフを楽しむロータリアン。● 2010年 米国 ● ロータリーの国際性を示すため、自国の伝統衣装をまとって国際協議会に参加するロータリアン。

사진 설명

소아마비 박멸에 앞장서다

2-3 페이지 ● 에티오피아 2002 ● 니제르 2006 ● 인도네시아 2007 ● 로타리의 폴리오플러스 프로그램은 수많은 사람의 목숨을 앗아가거나 불구로 만드는 소아마비로부터 어린이들을 보호하기 위해 시작되었다.

4 ● 인도 2008 ● (왼쪽) 소중한 소아마비 백신은 특수 용기에 보관된다; (오른 쪽) 로타리안들은 멀리 떨어진 오지의 소아마비 박멸을 위한 전략을 개발했다.

5 ● 인도 2008 ● 로타리안 자원봉사자들이 외딴 마을에 사는 어린이들에게 백신을 투여하기 위해 가가호호를 방문하고 있다.

6-7 ● 이집트 2004 ● 인도 2010 ● 네팔 2008 ● 국제로타리의 기금 지원을 받아 실시된 전국 면역의 날 행사에서 수 백만 명의 어린이들이 소아마비 백신을 투여받았다.

8-9 ● 에티오피아 2002 ● 인도 2006 ● 전국 면역의 날에 자녀들을 데리고 나온 어머니들이 차례가 오기를 끝기있게 기다리고 있다.

10-11 ● 에티오피아 2002 ● 소아마비 백신을 투여받은 소녀들이 물감을 칠한 새끼 손가락을 들어 보이고 있다.

12 ● 에티오피아 2002 ● 전국 면역의 날 자원봉사자들이 부모들에게 자녀를 데리고 행사장에 나오도록 메가폰을 잡고 호소하고 있다. **● 차드 2004 ●** 아프리카 소아마비 추방 캠페인(Kick Polio Out of Africa)은 아프리카 대륙 전체에 면역의 중요성을 일깨우는 중요한 역할을 했다.

13 ● 인도 2006 ● 소아마비 후유증으로 고통받고 있는 어린이들이 로타리가 후원하는 병원에서 재활 수술을 받고 있다.

14 ● 나이지리아 2002 ● 대문의 분필 자국은 이 집의 자녀가 소아마비 백신을 투여받았다는 것을 나타낸다.

15 ● 미국 2005 ● 로타리 창립 100주년 국제대회에 참가한 로타리안들이 소아마비 박멸 기금을 위한 마라톤 대회에서 역주하고 있다.

식량, 보건, 교육 등 기본적인 필요 충족

18 페이지 ● 우간다 2009 ● 고아인 세 자매가 로타리클럽들로부터 재정적 후원과 보살핌을 받고 있다.

19 ● 우간다 2009 ● 선한 사마리아인 학교에 재학 중인 학생들이 인근 로타리안들이 만들어준 교복을 입고 있다.

20 ● 우간다 2009 ● 로타리안 의사들이 말라리아 퇴치 및 보건 증진 프로젝트의 일환으로 주민들을 검진하고 있다.

21 ● 니제르 2006 ● 로타리의 지원으로 사가(Saga) 급식 센터는 가뭄을 비롯한 비상시기에도 지속적으로 영양식을 제공할 수 있었다.

22 ● 과테말라 2010 ● 펀다니나스 고아원의 소녀들이 굶주리지 않고 학교에 다닐 수 있었던 것은 로타리재단 보조금에 힘입은 바가 크다.

23 ● 도미니카 공화국 2009 ● 이 지역 로타리안들은 인근 2개 학교 어린이들에게 아침식사를 제공했다.

24-26 ● 아르헨티나 2009 ● 로타리안들은 지역 병원에 영아 청각 테스트 및 치료 장비를 지원했다.

27 ● 온두라스 2006 ● 허리케인 미치 이후, 로타리의 지원으로 건설된 누에바 에스페란자 지역 공동체의 한 가족이 공동체 내의 클리닉에서 진단을 기다리고 있다. **● 과테말라 2010 ●** 로타리안들의 지원으로 세워진 화상전문 아동병원에서 한 어린이가 손을 치료를 받고 있다.

28-29 ● 남아공 2006 ● 로타리안들의 재정지원으로 세워진 유치원은 에이즈 환자 가족 어린이들에게 무상으로 식사와 교육을 제공한다.

30 ● 루마니아 2006 ● 고아원의 어린이들이 로타리 프로젝트의 일환으로 제공된 우유를 마시며 즐거워하고 있다.

31 ● 루마니아 2006 ● 이 아동병원의 환자들은 로타리재단 보조금의 지원을 받는 인근 농장에서 고기와 유제품을 공급받는다.

32-33 ● 브라질 2007 ● 이 지역 학교들의 문해력 증진 프로그램과 급식 프로그램은 로타리재단 보조금의 지원을 받는다.

34 ● 터키 2006 ● 비야지트 도서관에 기증할 오디오 북 녹음 프로젝트에는 맹인 로타리안이 앞장섰다.

35 ● 터키 2006 ● 두 팔 없이 태어난 에민 뉴제이는 로타리 문해력 증진 프로그램 덕분으로 읽고 쓰기를 배웠으며, 지금은 다른 여성들을 지도하고 있다.

36-37 ● 아프가니스탄 2004 ● 로타리 스폰서하는 학교 덕분에 많은 소녀들이 난생 처음으로 학교 문턱을 밟을 수 있었다.

37 ● 방글라데시 2000 ● 로타리가 보급한 집중식 언어 교육법에 따라 많은 어린이들이 읽기와 쓰기를 효과적으로 터득하고 있다.

38 ● 인도 2006 ● 종합적인 프로젝트들에는 기본 교육이 중요 요소로 포함되어 있다.

39 ● 인도 2006 ● 빗물 저장 프로젝트는 식량 생산을 증가시키고 인근 농가의 소득 확대로 이어졌다.

40 ● 프랑스 2008 ● 로타리가 지원하고 있는 치매 노인을 위한 데이 케어 센터는 환자는 물론, 환자를 돌보는 가족들에게도 큰 힘이 되고 있다.

41-43 ● 미국 2007 ● 로타리안 자원봉사자들은 저소득층 지역을 돌아다니며 식품을 제공하는 이동 식품 차량을 운영한다.

깨끗한 물과 위생 시설의 제공

46-49 페이지 ● 인도 2006 ● 로타리재단의지원으로 로타리안들과 지역 주민들은 우물이 마르지 않게 하는 댐을 만들었다.

50 ● 도미니칸 공화국 2009 ● 한 로타리안이 물을 오염된 물을 정제하는 바이오-샌드 필터를 설치하고 있다.

51 ● 아르헨티나 2010 ● 로타리가 스폰서한 '깨끗한 손 프로젝트'는 어린이들에게 일찍부터 위생적인 습관을 심어준다.

52-53 ● 페루 2010 ● 로타리재단 보조금으로 구입한 100개의 바이오-샌드 필터는 물을 정제하여 1,500명에게 안심하고 마실 수 있는 물을 제공하게 된다.

54 ● 과테말라 2010 ● 로타리안들은 강가의 주민들이 안전한 식수를 마실 수 있도록 필터를 직접 들고 열대 우림 지역을 통과하여 주민들을 찾아갔다.

55 ● 페루 2008 ● 로타리재단 보조금으로 로타리안들은 안전한 식수를 공급하기 위한 옥외 물 저장 시설을 건설하였다.

56 ● 우간다 2009 ● 이 시추공은 질병 퇴치와 농사 개선, 빈곤 완화를 위한 로타리재단 대규모 프로젝트의 일환이다.

57 ● 방글라데시 2000 ● 한 어린이가 로타리안들이 파준 우물에서 깨끗한 물을 마시고 있다.

58-59 ● 니제르 2006 ● 로타리재단 보조금으로 설치된 우물은 세계 곳곳에서 소중한 생명샘으로 많은 인명을 구하고 있다.

청소년들에게 삶의 기술을 가르치다

62-63 페이지 ● 미국 2009 ● 스웨덴 2006 ● 라일라(RYLA) 프로그램은 청소년들과 젊은 성인들에게 다양한 방법으로 리더십을 함양할 수 있는 기회를 제공한다.

64 ● 캐나다 2009 ● 로타리가 스폰서한 PACT 프로그램은 범죄 전력이 있는 청소년들이 새로운 삶을 살아갈 수 있도록 지원한다.

65 ● 프랑스 2009 ● (위) 로타리가 스폰서하는 청소년 봉사클럽인 인터랙트가 추진하는 프로젝트에서 청소년들이 빵 굽는 방법을 배우고 있다; (아래) 프랑스 로타리 지역잡지가 스폰서하는 저널리즘 상은 장래가 촉망되는 젊은 저널리스트에게 영화를 제작할 수 있는 기회를 부여한다.

66 ● 미국 2007 ● 목수일을 배우는 젊은이들이 로타리 프로그램에서 단독 주택 짓는 법을 배우고 있다. 나중에 이 집을 판매한 기금은 장학금으로 사용된다. ● **브라질 2007 ●** 탈선 위기에 처한 청소년들이 로타리 프로젝트를 통해 전기 기술을 배우고 있다.

67 ● 미국 2009 ● 로타리가 스폰서하는 젊은 성인들을 위한 봉사클럽인 로타랙트 회원들이 장애 어린이들을 위한 놀이터를 설치하고 있다.

자연재해 지역에 내미는 구호의 손길

70 페이지 ● 태국 2005 ● 쓰나미 이후 로타리재단의 지원금은 어부들의 생업 복귀에 큰 보탬이 되었다.

71 ● 태국 2005 ● 로타리안 자원 봉사자들이 쓰나미 피해 지역에서 재건 활동에 힘쓰고 있다. ● **파키스탄 2010 ●** 로타리안들은 홍수로 집을 잃은 이재민들에게 쉘터를 제공했다.

72 ● 스리랑카 2005 ● 로타리안 자원봉사자들이 쓰나미로 대파된 집들을 다시 짓고 있다.

73-75 ● 스리랑카 2005 와 2009 ● 로타리의 학교 재건 프로젝트는 쓰나미로 대파된 학교를 대신하여 25개의 학교를 새로 세웠다.

76-77 ● 미국 2005 ● 허리케인 카타리나가 강타하자 로타리안들은 임시 숙소를 제공하고(왼쪽), 구호 용품과 생필품을 제공했다(오른쪽).

78 ● 미국 2008 ● 로타리안들은 산불 피해자들을 지원하고(위), 아이오아 홍수 이재민들에게도 도움의 손길을 펼쳤다(아래).

79 ● 페루 2010 ● 로타랙트 회원들이 지진 강타 후 잔해물들을 치우고 있다.

80-81 ● 아이티 2010 ● 아이티 지진 사태 후 로타리안들은 오갈 데가 없어진 수 백명의 이재민들에게 임시 숙소를 제공했다.

지구를 보전하라

84-87 페이지 ● 몽골리아 2008 ● 로타리의 '몽골을 푸르게' 프로젝트는 고비 사막에 방품림을 설치하는 것이다.

88 ● 일본 2009 ● 강물 정화를 위한 로타리 프로젝트에 참석한 학생들이 환경 보호에 관해 배우고 있다.

89 ● 미국 2005 ● 로타리클럽은 삼림 훼손과 환경 오염을 막기 위해 개발 도상국 주민들에게 태양열 오븐을 공급했다.

경제 개발 지원

92 페이지 ● 남아공 2006 ● 남아공 여성들이 로타리 프로젝트에서 구두 수선법을 배우고 있다. 이 프로젝트의 수익금은 에이즈 고아 센터를 돕는 데 사용된다.

93 ● 우간다 2009 ● 여성들이 로타리클럽이 제공한 기계를 사용하여 양재 기술과 모기장 만드는 방법을 배우고 있다.

94-95 ● 과테말라 2010 ● 로타리안들이 대규모 지역사회 개발 프로젝트의 일환으로 도서관을 짓기 위해 마야 지역사회 주민들과 공동으로 작업하고 있다.

96 ● 브라질 2007 ● 로타리재단이 지원하는 제빵학교에서는 학생들에게 제빵 기술과 판매 전략을 가르친다.

97 ● 과테말라 2010 ● 로타리가 지원하는 지역사회 내 여성 수공업자들이 기념품으로 판매할 그릇에 색칠을 하고 있다.

98-99 ● 온두라스 2006 ● 로타리의 재정지원을 받는 마이크로크레디트는 주민들이 양복점이나 식품상 등의 창업을 통해 경제적 자립을 이루도록 도와준다.

100-101 ● 인도 2006 ● 이 가족은 로타리가 지원하는 마이크로크레디트의 융자를 통해 작은 가게를 차리고 자립 기반을 마련했다.

봉사를 통해 우정을 나누다

104 페이지 ● 아르헨티나 2010 ● '깨끗한 손 프로젝트' 기획자들이 관련 자료들을 전시하고 있다.

105 ● 루마니아 2006 ● 로타리안 자원봉사자들이 로타리 프로젝트를 통해 가축을 받게 된 농부와 이야기를 나누고 있다. ● **인도 2006 ●** 소아마비가 퇴치된 국가의 로타리안들이 전국 면역의 날에 자원봉사자로 참여, 현지 로타리안들과 공동 작업을 펼치고 있다.

106 ● 과테말라 2010 ● 로타리안들이 고아원 후원 프로젝트를 위해 인근 농부들과 만나 계획을 논의하고 있다. ● **몽골리아 2007 ●** 로타리안들과 주민들은 환경 보호를 위한 프로젝트에 함께 참여한다.

107 ● 스리랑카 2007 ● 로타리안들이 노숙자들을 위한 숙소를 완공한 뒤 축하하고 있다.

108 ● 미국 2007 ● 로타리 국제대회는 전세계 로타리안들이 함께 모여 '초아의 봉사'를 축하하는 축제와 화합의 장이다. ● **캐나다 2009 ●** 클럽 주회를 통해 회원들은 프로젝트를 계획하고 우정을 다진다.

109 ● 일본 2009 ● 클럽 회원들의 골프 활동은 동료애를 진작시키는 좋은 방법이다. ● **미국 2010 ●** 국제협의회에 참석한 로타리안들이 각국의 전통 의상을 입고 로타리의 국제성을 과시하고 있다.

LEGENDAS

Erradicando a pólio globalmente

PÁGS 2-3 • ETIÓPIA 2002 • NÍGER 2006 • INDONÉSIA 2007 • O programa Pólio Plus do Rotary foi desenvolvido para salvar as crianças do mundo dos efeitos deformadores do vírus da pólio.

4 • ÍNDIA 2008 • *(à esquerda)* A vacina contra a pólio é preservada através do processo de rede de frio; *(à direita)* Rotarianos desenvolveram estratégias para erradicar a pólio nas mais remotas áreas.

5 • ÍNDIA 2008 • Rotarianos vão de casa em casa imunizando crianças.

6-7 • EGITO 2004 • ÍNDIA 2010 • NEPAL 2008 • Milhões de crianças recebem a vacina da pólio nos Dias Nacionais de Imunização patrocinados pelo Rotary International.

8-9 • ETIÓPIA 2002 • ÍNDIA 2006 • Mães esperam pacientemente para imunizar suas crianças contra a pólio.

10-11 • ETIÓPIA 2002 • Meninas mostram seus dedos pintados após receberem a vacina contra a pólio.

12 • ETIÓPIA 2002 • Em Dias Nacionais de Imunização, voluntários incentivam os pais a levarem suas crianças para serem vacinadas. • **CHADE 2004 •** A campanha Chute a Pólio para Fora de África aumentou a conscientização no continente africano sobre a importância da imunização.

13 • ÍNDIA 2006 • Crianças vítimas da pólio recebem cirurgia reconstrutiva e reabilitação em hospital patrocinado pelo Rotary.

14 • NIGÉRIA 2002 • Marcas de giz na porta indicam que as crianças desta casa foram vacinadas contra a pólio.

15 • ESTADOS UNIDOS 2005 • Rotarianos da Convenção do Centenário do Rotary participam de uma corrida para erradicar a pólio.

Atendendo a necessidades básicas de alimentação, saúde e educação

PÁG 18 • UGANDA 2009 • Irmãs órfãs recebem ajuda financeira e cuidados de Rotary Clubs.

19 • UGANDA 2009 • Estudantes de Escola Samaritana usam uniformes feitos por rotarianos locais.

20 • UGANDA 2009 • Médicos examinam pacientes como parte de um projeto rotário para diminuir malária, pobreza, fome e analfabetismo.

21 • NÍGER 2006 • Com o apoio do Rotary, o Centro de Alimentação Saga distribui alimentos.

22 • GUATEMALA 2010 • Subsídios da Fundação Rotária ajudam a educar e alimentar meninas do orfanato Fundaniñas.

23 • REPÚBLICA DOMINICANA 2009 • Rotarianos fornecem diariamente café da manhã a crianças de duas escolas.

24-26 • ARGENTINA 2009 • Um projeto rotário ajuda a prover testes auditivos e tratamento para crianças.

27 • HONDURAS 2006 • Uma família espera para ser atendida em um posto de saúde em Nueva Esperanza, comunidade construída pelo Rotary após o furacão Mitch. • **GUATEMALA 2010 •** Uma pequena mão recebe tratamento em um posto de saúde, patrocinado pelo Rotary, para crianças que sofreram queimaduras.

28-29 • ÁFRICA DO SUL 2006 • Uma creche financiada pelo Rotary fornece refeições e educação a crianças de famílias afetadas pela aids.

30 • ROMÊNIA 2006 • Crianças de um orfanato bebem leite doado através de um projeto rotário de agricultura.

31 • ROMÊNIA 2006 • Pacientes deste hospital infantil recebem carne e leite de sitiantes locais, com o apoio de um subsídio da Fundação Rotária.

32-33 • BRASIL 2007 • Programas de alfabetização e fornecimento de refeições nestas escolas acontecem graças a subsídios da Fundação Rotária.

34 • TURQUIA 2006 • Um rotariano cego coordenou um projeto para gravar audiolivros para a biblioteca Beyazit.

35 • TURQUIA 2006 • Nascida sem braços, Emine Yüzay aprendeu a ler e escrever através de um projeto de alfabetização do Rotary, e agora ensina outros.

36-37 • AFEGANISTÃO 2004 • Uma escola patrocinada pelo Rotary dá a meninas a oportunidade de receber educação.

37 • BANGLADESH 2000 • Crianças aprendem a ler através de Abordagem Linguística Concentrada, um método revolucionário introduzido por rotarianos em várias partes do mundo.

38 • ÍNDIA 2006 • Educação básica é um componente fundamental em muitos projetos integrados do Rotary.

39 • ÍNDIA 2006 • Um projeto de coleta de água aumentou as colheitas e ajuda a alimentar residentes de vilarejos locais.

40 • FRANÇA 2008 • Pacientes de Alzheimer participam de atividades desenvolvidas por rotarianos, planejadas para dar um dia de descanso aos familiares.

41-43 • ESTADOS UNIDOS 2007 • Rotarianos e funcionários do Rotary ajudam um banco de alimentos que atende a bairros de baixa renda.

Fornecendo água potável, saneamento e educação em higiene básica

PÁGS 46-49 • ÍNDIA 2006 • Com o apoio da Fundação Rotária, rotarianos e outros voluntários constroem um muro de retenção para evitar que poços sequem.

50 • REPÚBLICA DOMINICANA 2009 • Um rotariano instala um filtro bioareia para assegurar o fornecimento de água potável.

51 • ARGENTINA 2010 • Um projeto patrocinado pelo Rotary ensina as vantagens de adotar bons hábitos de higiene desde criança.

52-53 • PERU 2010 • Cem filtros bioareia, comprados com subsídio da Fundação Rotária e instalados por rotarianos, levarão água potável a 1.500 pessoas.

54 • GUATEMALA 2010 • Rotarianos atravessaram floresta tropical e instalaram filtros de água em comunidades ribeirinhas.

55 • PERU 2008 • Subsídios da Fundação Rotária financiaram a construção de pias externas para prover água limpa à comunidade.

56 • UGANDA 2009 • Este poço é parte de um projeto da Fundação Rotária para combater doenças, melhorar agricultura e reduzir o nível de pobreza.

CREDITS

Cedric Arnold 70

Jean-Marc Giboux 2, 3 (right), 6 (top), 8, 10-11, 12, 14

Rajesh Kumar Singh Front cover, 9

Mark Pearson 71 (right), 80-81

M. Kathleen Pratt 37, 57

Rotary Images iv-v, vi, 1, 6, 7, 44, 45, 60, 61, 68, 69, 82, 83, 89, 90, 91, 102, 103

 Alyce Henson Back cover, 3 (left), 4, 5, 7, 13, 15, 18-21, 23, 24-26, 28-33, 38-39, 41-43, 46-53, 56, 58-59, 63-64, 66 (top), 71 (left), 72-73, 76-77, 78 (bottom), 79, 92-93, 96, 100-101, 104-105, 107, 108

 Monika Lozinska-Lee 22, 27, 34-35, 40, 54, 58-59, 62, 65, 66 (bottom), 67, 78 (top), 84-87, 94-95, 97-99, 106, 109 (bottom)

Devaka Seneviratne 74-75

David Trilling 36

Jacket and interior design by Reiko Takahashi